HISTORIC COLUMBUS CRIMES

HISTORIC COLUMBUS CRIMES

MAMA'S IN THE FURNACE, THE THING & MORE

DAVID MEYERS & ELISE MEYERS WALKER

Published by The History Press
Charleston, SC 29403
www.historypress.net

Copyright © 2010 by David Meyers and Elise Meyers Walker
All rights reserved

First published 2010

Manufactured in the United States

ISBN 978.1.59629.215.4

Library of Congress Cataloging-in-Publication Data

Meyers, David, 1948-
Historic Columbus crimes : mama's in the furnace, the thing, and more / David Meyers
and Elise Meyers Walker.
p. cm.
Includes bibliographical references.
ISBN 978-1-59629-215-4
1. Crime--Ohio--Columbus--History--Anecdotes. 2. Murder--Ohio--Columbus--History--
Anecdotes. 3. Columbus (Ohio)--History--Anecdotes. I. Walker, Elise Meyers. II. Title.
HV6795.C7M49 2010
364.152'30977157--dc22
2010041894

Notice: The information in this book is true and complete to the best of our knowledge. It is offered without guarantee on the part of the authors or The History Press. The authors and The History Press disclaim all liability in connection with the use of this book.

All rights reserved. No part of this book may be reproduced or transmitted in any form whatsoever without prior written permission from the publisher except in the case of brief quotations embodied in critical articles and reviews.

CONTENTS

Acknowledgements 7
Introduction 9

1. The Resurrection War 11
2. Fightin' Words 17
3. Flytown Frenchy's Finale 24
4. Death Rides the Rails 30
5. Murder in Sellsville 36
6. In a Lonely Place 44
7. Insanity Comes Quietly to the Structured Mind 52
8. The Thing 59
9. Mama's in the Furnace 65
10. Beauty and the Brain 72
11. Blood Brothers 80
12. How Not to Write a Crime Novel 87
13. Think of Laura 93
14. The Buddy System 100
15. The Ninja Drag Queen Killer 108
16. The Day the Music Died—Again 114

Notes 121
Bibliography 125
About the Authors 127

AKNOWLEDGEMENTS

Columbus is fortunate to have one of the best public library systems in the nation. In researching *Historic Columbus Crimes*, we made liberal use of its resources. We would particularly like to thank Julie Callahan and Nick Taggart for their help and encouragement. All images from the Columbus Metropolitan Library's Digital Collections are marked (CML).

We are also grateful for the assistance of Officer Amy Morris and Detective David Morris (retired) of the Columbus Police Department. It is due to the tireless efforts of such dedicated law enforcement officers that we have fewer lingering mysteries than we might otherwise. Photos taken from police files are marked (CPD).

Additionally, we are indebted to Bob Parrott and the Union County Historical Society for the use of the photo of Forest Bigelow (UCH), the Franklin County Sheriff's Department for the photos of the Lewingdon brothers (FCS), the *Columbus Dispatch* for the photo of Laura Carter (CD), Sam Walker for the illustration of "The Thing" (SW) and Rebecca Felkner of the Grandview Heights Public Library for photos from the *Columbus Citizen/Citizen-Journal* Newspaper Collection (CCJ). All other images are from private collections (PC).

Finally, we would like to acknowledge Joe Gartrell of The History Press for inviting us to pitch a book to them. We hope it meets his expectations.

Historic Columbus Crimes is dedicated to Beverly Meyers, the wife and mother who puts up with and even encourages the nonsense that is involved in writing a book. (If she wouldn't read so many books, maybe people wouldn't write them.)

INTRODUCTION

It was a late Monday afternoon when Reverend Clarence V. Sheatsley gathered his children together for an impromptu family meeting. Unfortunately, their mother was unable to attend because, as he calmly informed them, "Mama's in the furnace."

The Sheatsleys seemed unlikely candidates for a domestic scandal, but Addie Sheatsley's bizarre death changed that. Suddenly, the most intimate details of their personal lives became a matter of public record—and fodder for neighborhood gossip. But the more mundane revelations are often as intriguing as the crimes themselves.

Whether or not Lizzie Borden "chopped up her mama and papa," I remain fascinated by the fact that the Bordens continued to dine on mutton that had been left out for several days. Similarly, my daughter (and co-author) is struck by Lizzie's always referring to their maid, Bridget, by the pejorative "Maggie." It is in such trivia that we discover the truth about who they were, irrespective of their guilt or innocence.

Crime cuts across all social strata, and in its wake, a window is opened up into the lives of people who may not, at first glance, be like us. Many of the incidents discussed in this book are from the distant past, and as L.P. Hartley observed in his novel, *The Go-Between*, "The past is a foreign country; they do things differently there." Medical students no longer have to double as body snatchers, and trolley car holdups are not the scourge they once were.

We have also included more contemporary crimes "ripped from the headlines," as they used to say. Some of these people "do things differently," too, but others may be uncomfortably like us or, at least, like someone we know. Consider the grieving widower held up as a role model in a Christian

Introduction

magazine even as he was "holding up" banks and armored cars. Or the college coed slain by a stray bullet while on her way to dinner with her parents, the unintended victim of a turf war between rival gangs.

The sixteen tales we have selected for *Historic Columbus Crimes: Mama's in the Furnace, the Thing and More* are some of the most sensational that have taken place in a city that is not generally known for sensational crimes. In fact, as recently as 1959, Columbus was proclaimed the most murder-free big city in the nation. Good for those of us who live here, if not for those who author true crime books.

But even the smallest town has its scandalous episodes, and as the sixteenth largest city in the country, Columbus has had its share. We trust that you will find them as interesting as we do.

CHAPTER 1

THE RESURRECTION WAR

On November 18, 1839, Patient No. 22 passed away at the Ohio Lunatic Asylum in Columbus. The record states that she was "much improved" since being admitted forty-eight weeks earlier—except, of course, she was now dead.[1]

Word was sent to the deceased's family in Marietta, Ohio, some 125 miles away, but the primitive roads, little more than muddy scars through the forest, were nearly impassable owing to the early winter rains. So the grim task of coming to claim the body was unavoidably delayed. Meanwhile, Patient 22—Sally Dodge Cram by name—was interred in a pauper's grave in the Old North Graveyard, just beyond the Columbus city limits.

Born December 26, 1783, Sally Dodge married Jonathan Cram at the age of twenty. Thirteen years later, the family moved from Hampton Falls, New Hampshire, to Marietta, Ohio, where Sally's father was a prominent member of the pioneer community. Jonathan became a merchant, and his store on the east side of the Muskingum River ferry landing prospered. However, when he died suddenly in 1820 at the age of forty-two, he left behind a thirty-six-year-old widow and four children, the youngest only five months old.

Over the next eighteen years, Sally's mind became increasingly unhinged. Rebecca, her eldest child and only surviving daughter, was largely responsible for raising her siblings. When she married at twenty-three, Rebecca took the youngest, Jacob, nine, to live with her.

By the time Sally was committed to the newly opened Ohio Lunatic Asylum on December 21, 1838, she had been suffering from "moral insanity" for three years. As the asylum directors later noted, the cholera epidemic of 1832–34 had given "a great impulse to whiskey and brandy drinking, of

Located one mile from the center of town on East Broad Street, the Ohio Lunatic Asylum admitted its first patient on November 30, 1838. (CML)

which the fruits were fully developed in 1839." Whether alcohol was a factor in Sally's mental instability, however, is speculative.

When Sally's family finally reached Columbus, they found her grave had been defiled and her body was missing. Two other graves had also been opened. Almost immediately, fingers were pointed at the Worthington Medical College by the school's enemies, of which there were many.

During the pre–Civil War era, Columbus was a hotbed of competing medical systems. There were, basically, two camps: the "regulars," or mainstream practitioners; and the "irregulars"—those who refused to go along with the accepted practices of the day. Although the regulars would ultimately prevail as the American Medical Association, it was often the irregulars who spearheaded needed reforms.

For example, the regulars advocated such later discredited procedures as bloodletting, blistering and medicinal doses of mercury and other poisons. The irregulars rejected such practices and introduced their own, which were sometimes just as silly or deadly but, occasionally, proved to be right.

The Worthington Medical College was modeled after the Reformed Medical College founded in New York by Dr. Wooster Beach. His Reformed System, which was strictly botanic (plant-based) at first, would eventually evolve into the Eclectic System through the efforts of Beach and Drs. Thomas Vaughan Morrow, Ichabod Gibson Jones and John J. Steele, all of whom had been trained as regulars. At a meeting of the Reformed Medical Society on May 3, 1830, they resolved to establish an additional school "in some town on the Ohio River, or some of its navigable tributaries."

The village of Worthington was but five years old when a charter was granted in 1808 for the establishment of a school to be known as Worthington

Academy. Eleven years later, a second charter changed the school's name to Worthington College. When one of Dr. Beach's circulars announcing his interest in locating a medical college in the "mighty west" fell into their hands, the trustees of Worthington College invited him to make use of their existing charter and building.

Dr. John J. Steele, "a reformed Allopathic [regular] physician of rare accomplishments," was dispatched to Worthington by Dr. Beach to examine the site and, if suitable, make the necessary arrangements to open the school. Following amendment of the charter, the new institution was opened for instruction in December 1830, with Dr. Steele as president. However, due to his "intemperate habits and moral obliquity" (i.e., fondness for "wine and women"), he was removed from that position by the following spring. His replacement was Dr. Morrow.

Only twenty-five at the time, Dr. Morrow was a man of "giant intellect" who proved to be a masterful leader. Born in Fairview, Kentucky, he was educated at Transylvania University in Lexington and then went to New York City to study medicine. It was there that he joined forces with Dr. Beach and held the chair of obstetrics at the Reformed Medical College. He was soon to become the leading medical reformer of the West.

Gradually, enrollment at Worthington College increased from seven or eight students the first session to forty by 1835–36. However, the school was not without its critics, especially among those who supported opposing views of medicine. It came under frequent attacks by the Thompsonians, followers of Samuel Thompson. In 1824–25, "Dr." Thompson originated the Thompsonian system (also known as "steam and puke"). He claimed, "Heat was life and cold was death." For twenty dollars, the purchaser of his book received the right to practice medicine in his own family and the immediate neighborhood. Thompson did not believe in medical schools, so a "diploma" was printed in the back of the book.

The Thompsonian system was popularized in Ohio by Horton Howard, a Columbus resident, who "held the patent for Ohio, several southern states, and the entire west."[2] Following Howard's death, Dr. Alvah Curtis inherited his mantle when he moved to Columbus in 1834. Ostensibly a Thompsonian, he opposed Thompson's anti-intellectualism and advocated the founding of schools to teach his own system. On March 8, 1839, Curtis obtained a charter for the Botanico-Medical Institute of Ohio. Several months later, he opened the College of Physicians and Surgeons in direct competition with Worthington Medical College.

Criticism of the activities of the Worthington Medical College had long found a home in the pages of the *Thompsonian Recorder*, founded in 1832

by Jarvis Pike. It was accused of advocating many of the same practices espoused by the regular doctors. Ironically, Morrow also had to defend his school against those who accused them of being "steam doctors."

Finally in 1836, the school launched its own monthly journal, *The Western Medical Reformer*. An article by Dr. Morrow stated: "There are now, in different sections of the United States, about 200 regularly educated, scientific medical reformers who have gone forth from New York and Worthington schools, besides a considerable number of old school physicians who have come out and openly declared themselves decidedly in favor of the improved, or botanical, system of practice, so far as they have been able to become acquainted with its principles."

The same year, Dr. D.L. Terry, a graduate of Worthington College who had been taken into partnership by Dr. Morrow, began to "sow seeds of discontent among the students" and soon went over to the Thompsonians. He became an outspoken critic through letters to the *Botanical Recorder* edited by Dr. Alvah Curtis, who had branded the doctors of Worthington College "the poisoning, blistering, cupping, bleeding, mongrelizing Beachites or eclectics."

Similarly, in 1838, Dr. Richard P. Catley replaced Professor Truman E. Mason as the chair of anatomy and operative surgery before joining forces with the Thompsonians. Having relocated fifteen miles north to Delaware, Ohio, Catley began stirring up the public about the manner in which the students were procuring bodies for their anatomy classes.

Of course, the Worthington Medical College obtained anatomical specimens no differently than other medical colleges of the day. Still, Reverend J.H. Creighton, who was attending the school during this period, later wrote

George Eels owned a copy of *An Introduction to the Study of Human Anatomy* by Winslow Lewis Jr., MD, while a student at Worthington Medical College. (PC)

that the acquisition of bodies "was mostly managed by students and some of them were very intemperate and reckless"—especially those "from the Southern States."

The basic problem was this: in order to be a competent physician, it was critical to have knowledge of anatomy. However, the legislature had not created any means for the schools to obtain anatomical specimens in a legal manner. The faculty at Worthington Medical College insisted that all grave robbing be restricted to those buried in potter's field in the belief that it would be less of an affront to public sensibilities.

Unlike for the Ohio Medical College, the legislature had not appropriated any funds to support the Worthington Medical College. In truth, the building itself—a two-story, rectangular brick structure painted red and topped by a cupola with a bell—was not well suited for its purpose and was in much need of repair. It also was becoming increasingly evident that Worthington was too small a community to become a great medical center.

Owing to the barrage of negative publicity, the college started losing students. In 1838, publication of the *Western Medical Reformer* ceased, and the infirmary closed. Nevertheless, the residents of Worthington continued to hold a favorable view of the school, so it was much easier for its enemies to garner support in more distant communities.

The final showdown came about when a lawyer named Thomas Watkins Powell delivered a highly inflammatory speech to a group of men who decided to mount an attack on the college. Powell, originally from Glamorganshire, South Wales, had been practicing law in Delaware since 1830 and would soon be elected to the state legislature.

A notice published in *Daily State Journal* on December 31, 1839, read:

> *Whereas, the citizens of Delaware and Franklin counties have been frequently for several years past, outraged in their sentiments and feelings by the conduct of the officers and students of the Worthington Reformed Medical College, in robbing the graves of the vicinity, and disturbing the dead of their last repose in taking our friends, wives, or daughters, when consigned, by their relatives with religious solemnity and the affections of near and dear friends, to the tomb, as subjects for dissection: And whereas it is the sense of this meeting that to permit or suffer this conduct any longer to exist or again to outrage our feelings, and thus to call forth the indignity of public opinion with impunity, would be a total abandonment of our duty as citizens, and of our moral sense of that regard due to our kindred dead.*

Those in attendance resolved to recover the dead body of Mrs. Cram ("mutilated though it may be"), close the medical college, compel the students to leave Worthington and reclaim the building for its original purpose, i.e., a high school or academy.

Just before Christmas, Dr. Morrow learned that a mob from Delaware, incited by Thomas Powell's speech, was on the march. The students and their friends proceeded to take up pistols, shotguns, rifles and other firearms while barricading themselves in the college building. Upon their arrival, the unruly crowd first turned its attention to searching the house and office of Dr. Morrow. While they found nothing inside, the body of a black man was discovered out back, concealed in a freshly cut shock of corn.

The vigilantes then began constructing battering rams for an all-out assault on the front door of the institution, while Dr. Morrow and the students prepared to defend the college at all costs. But when word reached him that someone had given the angry citizens a key, Morrow stepped outside and announced they would surrender, providing the faculty could leave the school with whatever equipment and furnishings they could carry. His terms were accepted.

Upon entering the school, Powell's mob found what was believed to be the body of Mrs. Cram lying upon a table, partially dissected. They turned the remains over to her family who, subsequently, took them back to Marietta for burial in Mound Cemetery.

In the aftermath of "The Resurrection War," as it came to be called, it was discovered that the original charter of the school did not include a provision for conferring medical degrees. So a bill was passed in March 1840, on a vote of thirty-four to thirty-one, denying Worthington College the right to do so.

Undismayed, Dr. Morrow continued to instruct students in his Worthington home until 1843, though for all practical purposes the school never reopened. He was then persuaded by Dr. Alexander H. Baldridge, an 1832 graduate of the college, and a Mr. Mills to move the institution to Cincinnati, where it was renamed the Reformed Medical School of Cincinnati or the Cincinnati Eclectic College.

Dr. Morrow was still teaching medicine up until the time of his death in Cincinnati on July 16, 1850, but it would take thirty more years for the Ohio legislature to come to grips with the need for medical schools to acquire anatomical specimens.[3]

CHAPTER 2

FIGHTIN' WORDS

"The pen is mightier than the sword," wrote Edward Bulwer-Lytton in his 1839 play, *Richelieu; Or the Conspiracy*. Ever since, the truth of this adage has been periodically tested, particularly by members of the press and, sometimes, with deadly results.

One of the earliest known local incidents occurred in 1840, when Colonel James Allen of the *Ohio State Journal* "received a trouncing from T.J. Buchanan, the Speaker of the House of Representatives, for bringing a lady into a political contest." Not long afterward, Colonel M.H. Medary of the *Statesman* "flogged" Oren Follett of the *Journal*, Dr. Miller of the *Old School Republican* assaulted V.W. "Bot" Smith of the *Ohio State Journal* and Medary "caned" John Teesdale, who had succeeded Smith at the *Journal*.

In 1855, George M. Swan, editor of the *Elevator*, attacked John Geary, his counterpart on the *Fact*. Nine years later, an editor of the *Fact* was roughed up by O.B. Chapman, editor of the *Union League*. The same year, the editor of the *Ohio State Journal* was "cowhided" by a woman he had previously referred to as "a long, lean, lank, sallow-complexioned she-rebel." This time, the editor's wife returned the favor by going after the woman with a buggy whip.

On two occasions, Chauncey Newton of the *Cincinnati Enquirer* was attacked on the city's streets by members of the legislature. However, he was able to walk away each time. Captain John Arthur of the *Sunday News* was not so lucky. On February 5, 1875, his skull was crushed when he was struck between the eyes with a blunt instrument. He died the next day.

Responding to these incidents, two of the city's most prominent ministers, Reverend Francis E. Marsten of the First Presbyterian Church and Reverend Washington Gladden of the First Congregational Church,

preached sermons on "immoral" journalism. Obviously, public sentiment was on the side of those defending their honor against the "yellow press." So when Robert B. Montgomery went after F.A. Brodbeck of the *Sunday News*, no charges were pressed.

William J. Elliott of the *Sunday Capital* was no stranger to such conflicts. On June 12, 1882, Edward Eberly took offense to an article that appeared in Elliott's paper and attempted to exact revenge. Then on November 8, 1885, the Honorable Emil Kiesewetter fired two shots at Elliott in the lobby of the Neil House Hotel. In a hearing before Mayor Charles C. Walcutt, all charges against Kiesewetter were dismissed on the grounds of "provocation."

But on February 23, 1891, it all came to a head. Elliott and his brother, Patrick, encountered Albert C. Osborn of the *Sunday World* on High Street opposite the Statehouse. Opening fire with their revolvers, they killed him. In the melee, Washington L. Hughes died and a number of other bystanders were injured.

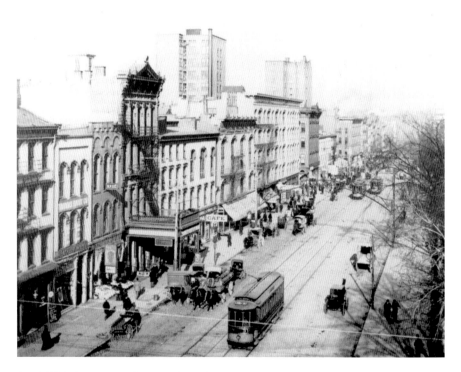

South High Street across from the State Capitol, much as it looked at the time of the shootout between the Elliott brothers and Albert C. Osborn. (CML)

Mama's in the Furnace, the Thing and More

For several years, William J. Elliott had been owner and editor of a newspaper called the *Sunday Capital*. During much of that time, he had in his employ a man named Albert C. Osborn. However, about a year earlier, Osborn had left the *Capital* to work for F.W. Levering at a rival paper, the *Sunday World*. Both newspapers were noted for their reliance on sensationalism, and much of it poured from the pens of Elliott and Osborn. It wasn't long before the two men were sharing their rather low opinions of each other with their readership.

No one is sure who started it. Elliott claimed Osborn was the aggressor and that he had endured many months of personal abuse before he offered a rejoinder in the pages of his newspaper. Whether it was so or not, there is no question that once he took up the gauntlet, the conflict escalated.

On February 8, 1891, Elliott prepared a two-column article in which he accused Osborn of being a "thief," among other things inconsistent with "good morals" and "honest citizenship." At the behest of Osborn's employer, the Honorable John McBride called on Elliott as a friend and asked him to refrain from printing any additional inflammatory articles. In exchange, he guaranteed the *Sunday World* would cease printing anything derogatory about him.

Unfortunately, the very same day, an article was published in the *World* in which Osborn continued to slander Elliott. And in a letter dated February 10, he warned Elliott: "I stand alone in the world, and am not very thin skinned. You have a wife and family and brothers and sisters behind you, and, although I have nothing against your family, if I am compelled to fight, I propose to strike you where it will hurt you the worst."

In retaliation, Elliott printed the previously suppressed article "to punish Levering for his bad faith." Furthermore, he challenged Osborn and Levering "to publish any damaging facts or atrocious lies they were capable of inventing about himself, and they would neither be assaulted nor sued for libel, but any attempt to drag in innocent parties or involve Elliott's family would be met differently, and he should then enact a husband and a father's part." This was on February 15.

The following day, Elliott took a Hopkins & Allen revolver from his Arlington home to Park's gun store for cleaning. He also purchased a new Smith & Wesson, which he had with him when he made a trip to the courthouse and then to Zwerner's drugstore. He informed the four gentlemen assembled there that he would kill Osborn if he answered his article of the day before.

A week later, February 22, 1891, the *Sunday World* accused Elliott of "drunkenness, lewdness, domestic brutality, and everything imaginable

tending to disgrace and humiliate a man, while the female members were indiscriminately charged with unchastity," not excepting Elliott's late mother.

Up bright and early on Sunday, Elliott dashed about the city in search of "newsboys" so he could gather evidence of the libel against him. Again, he was armed. At city hall, he mentioned to a couple of men that he would like to know where Levering and Osborn lived and then raised the pistol over his head and said he would "shoot the sons of bitches if he had to follow them into church."

One of the men, William P. Taylor, gave Elliott Levering's address but mistakenly said that it was 102 North Third Street, when it was actually 102 North Fourth. Consequently, Elliott failed to find it. Doubling back, he picked up his brother, Patrick, along the way. They continued their futile search for Levering's residence before finally giving up and going home.

Several witnesses claimed that in the days leading up to the incident, Osborn had also openly made threats against Elliott. Joe Fawcett, for one, quoted Osborn as saying, "I will make the coward shoot me or I will shoot him. I am prepared. I expect it to end in a shooting scrape." However, P.H. Sandusky, a barkeeper at McCabe's Saloon, felt that Osborn was joking to relieve the obvious tension in the air.

The next day, Osborn was standing near Savage's Jewelry Store when a man warned him to take care because Elliott was coming. Osborn purportedly replied, "Let him come, damn him, that is what I am waiting for." Osborn's friend, Robert Wolfe, went so far as to purchase a revolver and ammunition for him (the latter only an hour before the fatal showdown).[1]

The final face-off took place at about 1:30 p.m. on Monday, February 23, 1891, even as the annual Washington's Birthday parade was moving slowly down High Street in front of the state capitol grounds.

As far as can be determined, the Elliott brothers were walking south along High Street, separating when they reached the Law Building. William continued on. Witness Henry A. Guitner placed Patrick at the curb in front of Tom Marshall's place, facing west, some thirty-five feet from the Law Building. Two men with him were facing east.

Continuing north along High Street, Guitner spotted Osborn at the foot of the stairway talking with someone as he passed the Law Building. After making a telephone call from Zelotes Wood's office farther up the street, he came out onto the stairway of Wells Post Hall, just north of where Hughes was standing. A few minutes later, he saw William Elliott passing in the crowd going south. Not long afterward, the shooting commenced.

Patrick had been stalking Osborn, working his way past the Neil House Hotel and the Odeon Building to the Law Building. When he did not see

Osborn, he waited on the sidewalk. Meanwhile, Osborn was emerging from Bott's Restaurant. When he reached the stairway of the Law Building, Patrick hurried back to the vicinity of the Neil House to retrieve his brother.

At the time, an estimated four thousand people were in downtown Columbus, and the newsmen were in the middle of the throng. Osborn was standing in the hallway of the Law Building, discussing the series of sensational editorials with several people. When he spotted the brothers approaching, he said either, "There come—" or "There are the Elliotts."

Osborn looked to the right, saw Patrick and remarked, "Here comes Patsy, now." William, in the meantime, moved through the crowd and raised his pistol, pointing directly at Osborn. Captain John W. Burton, watching from the window of his office over Savage's Jewelry Store, said a shot was fired and he saw smoke curling from William's gun. James A. Miles, who had his eyes on William as he approached, testified that William fired two shots before Osborn got off one.

A woman, Blanche Wilson, claimed Elliott had hold of her shoulders when he fired, using her as a shield. Osborn was struck in the chin, the ball shattering the bone and passing into his neck, lodging near the jugular vein. Staggering, he squeezed off a couple of shots, one of which is believed to have struck the curb and the other the knee of medical student Reif Snyder.

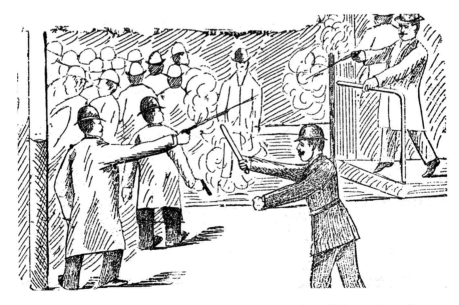

This newspaper artist probably did not witness the gun fight but relied upon the testimony of others and his imagination. (PC)

Meanwhile, Patrick approached from the middle of the street, where he testified he had retreated when the shooting broke out. Osborn's third shot struck Patrick in the arm, and the fourth or fifth hit him in the back. As Osborn fled sixty feet into McDonald's Hat Store, Patrick scrambled after him, firing as he went.

Immediately upon entering the store, Osborn leaned against the wall, glancing back through the doorway. Gathering himself up, he stumbled across the room and braced himself against a showcase. Mr. Sylvester, a clerk, immediately fled out the rear door. Osborn attempted to follow him.

Charging through the front doorway, Patrick fired a shot that struck a hatbox. Osborn and Patrick then clinched one another in a desperate struggle, and Osborn was shot again, this time through the heart. There was no disputing that Osborn had been in retreat since the incident began and the Elliotts had been pursuing him.

Highly agitated, William emptied his gun—five chambers—before he was arrested by a police officer. He resisted the officer's efforts to restrain him, forcing himself forward to where Patrick and Osborn were locked in an embrace. Several witnesses testified that William called to his brother, "Kill him, Patsy, kill the son of a bitch." However, William insisted he was saying, "Let me go, the son of a bitch will kill Pat."

One of William's shots had struck the stone post in the north side of Schrader's Billiard Room. One passed through the leg of John Rees and into the McDonald's hat sign. One cut through Sullivan's arm and glanced off Smith's sign. And one lodged in the brain of Washington L. Hughes, an innocent bystander.

As he was being transported to city prison, William held up a cigar between two fingers and told Officer Frank Wolf, "It is the same cigar I had when I done that shooting. You can see that I wasn't in any way excited over it. It is the same cigar I had in my mouth."

Indicted on two counts of first-degree murder, William was convicted of second-degree murder in the slaying of Osborn. The indictment for the murder of Hughes was "nollied" (dropped for lack of evidence). His brother, Patrick, was tried under like indictments. He was found guilty of manslaughter in the death of Osborn and acquitted of the murder of Hughes. Sentenced to twenty years, he was paroled after four.

Under a change of venue, Patrick's trial was held in Lancaster, thirty miles southeast of the city. He testified that he had come to Columbus from Cincinnati to watch over his brother from Sunday afternoon, February 22, until the time of the shooting. He acknowledged that William was extremely

Mama's in the Furnace, the Thing and More

During his stay at the Ohio Penitentiary, William J. Elliott was something of a celebrity, particularly to those who paid to take tours of the prison. (PC)

angry and irritated by the libelous writings of Osborn and he was trying to keep watch over him until he cooled down.

While in prison, William continued to write and was the object of considerable curiosity. Unfortunately for him, not all of it was positive. At his parole hearing after he had spent seven years in prison, it was alleged "that the applicant is broken in health and spirit, that he is over 52 years of age, that he lost an eye and was otherwise disabled by the vicious assault of a fellow prisoner, who threw vitriol into his face and eyes in revenge for Elliott's reporting and frustrating a scheme for a wholesale escaping of prisoners from the penitentiary."

Pardoned on the condition that he leave the state, William relocated to Washington, D.C., where he resumed his muckraking ways. In 1901, he founded the first of several short-lived publications, the *Sunday Globe*, followed by the *Graft* and, finally, *Washington Magazine*. After that the trail grows cold.

CHAPTER 3

FLYTOWN FRENCHY'S FINALE

Charles Deering (or Dearry), alias Dumont, was a twenty-four-year-old career criminal who settled in the Flytown section of Columbus in January 1899, following his release from the Ohio Penitentiary. It was his second term. He had originally been sent up on thirty-two charges of burglary and larceny. While in prison, he was cited for thirty-eight separate rules infractions. Obviously, Dumont couldn't adjust to life either in or out of prison.

Flytown was the name given to the area bounded by North High Street on the east, the Olentangy River on the west, Buttles Avenue on the north and Spruce Street on the south. So called because the buildings would seemingly "fly up" overnight, Flytown was the melting pot of the community. Here, Irish, Germans, Welsh, African Americans, Italians and a dozen other nationalities lived side by side in relative harmony. To "Frenchy" Dumont, as he was known, it was the land of opportunity.

In short order, Dumont established himself as the toughest guy around, although he was only five feet, six inches tall. By June, he had been arrested again for the possession of burglary tools and a ring of skeleton keys. His modus operandi was to burglarize north end homes while their owners were in church. However, when he protested that he "wasn't on to anything crooked," Detective Abe Kleeman and several other officers recommended he be turned loose. And he was, but with the stipulation that he report to police headquarters every morning.

For a while, Dumont complied—and then one day he didn't. After a burglary was committed at the far west side home of Mr. and Mrs. G. White on Oakley Avenue, a pawnbroker who bought a stolen watch belonging

to the victims described the seller as a man who fit Dumont's description. Others had placed a similar-looking stranger in the Whites' neighborhood prior to the theft. Dumont had last been arrested June 22 on suspicion of having burglarized Lyon's Saloon, but a case could not be made against him.

An order went out from police headquarters to bring Frenchy in. This was not a task for the faint of heart. The residents of Flytown were accustomed to hearing the sound of Dumont's .32-caliber pistols at a shack down by the Olentangy River, where he fired at rocks, trees and whatever floated by. Many had heard him boast, "I'll kill the first cop who tries to take me in!" Few doubted him.

Suffering from consumption and addicted to opium, Dumont was soon cornered by a couple of officers in a house at Harrison Avenue and Goodale Street. He quickly realized that the two men, Victor P. Churches and Henry James, were unarmed and got the drop on them, threatening to "blow their heads off." They quickly fled, returning a short while later with some firepower of their own. But Dumont had not waited around.

A game of cat and mouse ensued as Dumont made the rounds of saloons, always staying one jump ahead of his pursuers. Some said he believed he was a second Jesse James, and others said that he was "never right in the head." A few encouraged his bravado, suggesting he ought to kill all the cops.

On Sunday, September 10, 1899, Officer Churches finished dining with his family at 477 West Goodale Street and struck out on foot for the city prison at Town and Scioto Streets. Word had reached him that Frenchy was on the move. As he neared the intersection of Harrison and Goodale, Churches spotted Dumont pedaling toward him on a bicycle.

Churches did not feel he could take the desperado by surprise since he was in uniform, so he hopped aboard a streetcar and went straight to

Located at the northwest corner of West Town and Scioto Streets, the Columbus City Prison opened on January 1, 1880. (CML)

headquarters. Reporting what he had seen to Inspector Thomas G. Baron, Churches was instructed to remain behind because Dumont knew him too well. Detective Abe Kleeman, age thirty-two, who was present in the inspector's office, said, "I guess I'll go on up there."

It is not known when Kleeman joined the police force, but it must have been within the last year or so. He had previously been a jeweler and, according to an article in the *Jeweler's Circular* of July 21, 1897, had been robbed by an employee, Ernest Glouser, who stole a watch and pawned it. In an issue dated April 26, 1899, it was reported that Kleeman was about to be appointed secretary to the chief of police, Macy Walcutt.

Both Baron and Churches cautioned the young detective about attempting to apprehend Dumont by himself, so Kleeman asked Detective George H. Gaston to accompany him. Churches told them they were likely to find Frenchy in the vicinity of Harrison Avenue and Poplar Street, just north of Goodale.

Ed Van Dyke was in William Woodruff's saloon at 700 Harrison Avenue when he heard someone shout, "Let's all have a drink!" He turned to see Dumont standing with his guns drawn and pointed at them. He had entered by a side door because the law required that the front doors of saloons be kept closed on Sundays. Discretion being the better part of valor, the men assembled in the saloon dutifully had a drink with "Frenchy" Dumont.

After he had downed his beer, Dumont broke the silence by remarking, "I just saw that _____ Italian [Churches] and had a notion

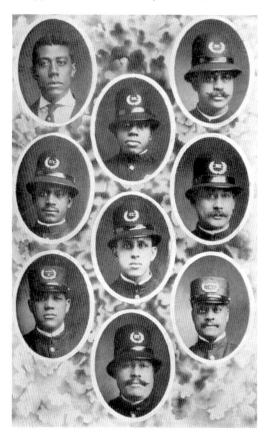

In 1900, the CPD included a number of African American officers, including John H. Jones (center) and George W. Gaston (center right). (PC)

to take a shot at him." He then took the two pistols that were lying on the bar in front of him, slipped them into his pockets and left the way he had come in. He picked up his bicycle, which he had parked beneath a grape arbor, and rode west on Poplar Street.

Arriving at Harrison and Poplar, Kleeman stationed himself on the northeast corner and Gaston on the southeast. It was about five o'clock. As Gaston later recalled from his bed at Protestant Hospital, "Kleeman and I were standing at the corner of Harrison and Poplar talking about Dumont when Able suddenly exclaimed: 'There comes Dumont on a wheel!'"

Whatever mission Dumont was on will never be known. He had just passed this way when he left Woodruff's saloon and, now, was returning. Perhaps he intended to visit a girlfriend. He had many; Dumont boasted that his "French" blood flowed hot "like wine." One in particular lived east of High Street, just outside Flytown. The officers watched as he hurriedly pedaled toward them on a bicycle (stolen, as it turned out, in New Albany earlier in the day).

"At that time I shouted to him to stop or I would shoot," Gaston said. Steering his bike with his left hand, Dumont drew a pistol from his hip pocket with his right and fired. "I aimed at his legs to stop him, as I did not want to kill the man," said the officer. "I shot twice and must have hit him in the legs, as he ran into a telegraph pole and fell."

By this time, Van Dyke and the other saloon patrons had flooded into the street. According to Van Dyke, Frenchy rounded the corner onto Poplar heading eastward, hopped off the bicycle and then drew his revolvers. Despite being struck in the legs, Dumont quickly rose to his feet, guns blazing.

"One of his shots struck me in the arm," said Gaston, "but I never fell until a ball struck me in the nose." He did not witness the ensuing battle between Dumont and Kleeman.

By his own account, Kleeman did not shoot until Gaston fell. Although a bullet had pierced his own chest, he walked toward Dumont, who was lying in the street, but stumbled and fell before he could reach him. At this point, Kleeman was heard to say, "Let me at him again."

"When I got to my feet some men were leading Kleeman away," Gaston stated. "I could see nothing of Dumont. Abe hit him, I think, after I fell. I could feel the bullet that hit me in the nose in the back part of my neck."

Van Dyke helped Kleeman into a chair on the sidewalk that someone had fetched from the saloon. "Kleeman showed me where he was hit," said Van Dyke. "It was in his side; I remember looking at the hole the bullet had made through his clothes. Abe had on a brown checkered suit. He said to me: 'I'm afraid it's fatal.'"

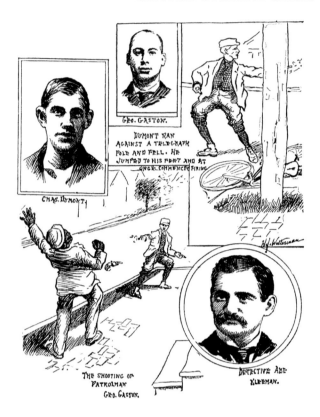

Harry James Westerman, one of the city's best illustrators, captured all of the principal players and the main action in the shootout. (PC)

As soon as the gunfire ceased, one of the bystanders called police headquarters. When Charles Seeds arrived with the Number One patrol wagon, Kleeman was in great pain. "Take me home," he said, "I am going to die and I want to draw my last breath in the presence of my family." Seeds transported the dying officer to his home at 689 South Ohio Avenue. Mace Smith, a resident of West Goodale Street, loaded Gaston into a nearby buggy and drove him to Dr. Hendrickson's office nearby. The physician advised him to go to Protestant Hospital, but the officer declined Smith's offer to drive him there. Instead, he walked three blocks to the hospital with Smith's assistance.

In response to reports of the shootout, two riot squads were dispatched to the scene, including Detective Sergeant Patrick Kelly, Detective Thomas Foster and Officer Churches. But Dumont was nowhere to be found.

Foster was a resident of the neighborhood. His wife had taken it upon herself to follow Dumont as he fled east on Poplar Street and attempted to hide in some weeds. Frenchy got as far as a "tube factory," where he again collapsed. He then dragged himself up a flight of stairs on the outside of the

building. Dan Murphy, one of his friends, called out to him, "Don't shoot, this is Dan," and proceeded to disarm him.

Later, Murphy went from hero to goat when he objected to the officers moving Dumont from an ambulance to the patrol wagon. Arrested for drunkenness and resisting arrest, he was subdued by a blow to the head with a blackjack. Meanwhile, Dumont was driven to the Protestant Hospital.

Frenchy was in bad shape. His screams of agony, interspersed with tirades of profanity, rang through the halls of the hospital. "For God's sake don't touch me until you give me an opiate," he pleaded. He also asked for someone to bring his girlfriend, a woman named Staley who lived on Harrison Avenue, to see him, but he either died before she could be summoned or she refused to come. He told authorities he had hidden at her house on several occasions.

Gaston and Kleeman had shot the young criminal six times: once in the heel, twice in his left leg, another in the pelvis and two in his chest. Fully conscious all the while, Dumont ordered the doctors to "cut the clothing from my body, and let me get a long breath, and then Dumont will bother you no more in this world."

Despite the efforts of police surgeon Dr. Thomas Grant Youmans, Dumont died at 9:30 p.m. Concealed in his clothes were a .32-caliber Ivor-Johnson five-shot revolver, a Forest City razor, three knives, two rings of house keys, five silk handkerchiefs and the names and addresses of several women. The other gun he used in the battle was never recovered.

Five days later, Officer Kleeman died of peritonitis. Dr. Starling Loving had feared a bullet was lodged in the detective's liver when he could not locate it. A member of one of the city's first Jewish families, Kleeman was thirty-two years old at the time of his death.

Abe Kleeman had previously gone into business on North High Street with his older brother, William, who had provided the police with valuable assistance in identifying crooks and recovering stolen property on an unpaid basis. Abe soon followed in his brother's footsteps. When Macy Walcutt was appointed chief of police, he hired Abe, badge No. 77, as a detective based on the shrewdness he had demonstrated. He became the second officer to die in the line of duty.

Gaston, one of the city's first African American police officers, was released from the hospital a couple of days later, just in time to attend his colleague's funeral. He remained with the department until his retirement in 1932. When he passed away on August 19, 1942, he still carried a souvenir lodged in his neck—the bullet that had hit him in the nose. "At times it bothers me," Gaston later said, "but I rub it like you would a sore muscle and the pain goes away."

CHAPTER 4

DEATH RIDES THE RAILS

On Friday, August 11, 1900, at 11:40 p.m., Pennsylvania passenger train No. 8 from St. Louis rumbled into Union Station in Columbus. Waiting to meet it was extra messenger J.M. Sheldon of the Adams Express Transfer office. Sheldon was surprised to see that his counterpart, Charles Lane, had failed to open the side door of the express car as was customary when the train was pulling into the station.

Pushing back the door, he quickly discovered why. The body of Lane was lying facedown in a pool of blood between the stove and the wall at the forward end of the car. He had been shot eight times. It appeared he had engaged in a terrific struggle before he died.

After the express car was detached from the train, the eastbound flyer continued on to New York with a replacement crew. The regular crew was detained by railroad detectives while awaiting the arrival of the Columbus police and coroner.

There were two safes on board. One, the local, had been opened and looted of anything of value, save for Lane's revolver, which had two or three empty chambers. There was also a note dated June 19 that read: "If I am rendered unconscious or killed, my name is Charles Lane; I reside at 244 W. Fourth Ave., Columbus; my age is 28; weight, 139 pounds; height, five feet, nine and one-half inches." Lane had recently moved from St. Louis to Columbus with his wife and child.

Authorities speculated that the robber (or robbers) had obtained the key to the safe from Lane's pocket after killing him and had placed his gun in the safe afterward. The other safe, which had been locked at St. Louis, remained untouched. The robber had also ignored thirty-five bars of silver bullion headed for the United States mint at Washington, D.C.

Mama's in the Furnace, the Thing and More

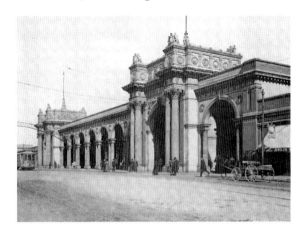

The third (and last) incarnation of Union Station was located on North High Street, site of the present-day Convention Center. (CML)

It was further speculated that the murder was committed just after the train left Milford Center, some twenty-eight miles west of Columbus. The conductor, a man named Jerry Taylor, said he had spoken with Lane at that time. Since Lane's body was cold and the blood had already clotted when it was discovered, they theorized that the robber had boarded the train at that time (the side door had been left open due to the heat) and quickly committed the crime. He then could have made his escape at either Plain City or Marble Cliff, the only two stops prior to arriving in Columbus.

John Fletcher, the baggage master, had been riding in the car directly behind the express car. He made the following statement:

> *After we left Urbana everything went well until we reached Capell, where we made a stop. I heard talking there. The speakers first appeared to be coming along beside the train, there being two or three of them. One man stepped on a piece of rotten wood, which attracted my attention just before the train got under way. We stopped at Plain City and Milford, and I heard no unusual sounds. After we left Plain City, I thought I would wash up and tried the door to the express car, but found that it would only move about an inch. I concluded that Lane had freight against it. We stopped at Marble Cliff, and there I saw two men running toward the train. One was an old man and the other a young fellow. Both were dressed in dark clothes.*

The call immediately went out to all police departments within fifty miles to assist in capturing the perpetrators of the crime. The entire local detective force, as well as those of the railroad and the Adams Express Company, began to interview every suspicious character in the area. One of the investigators was Thomas E. Foster of Columbus, "the Buckeye Detective."

CHARLES R. H. FERRELL,
The man who robbed the express safe and murdered Messenger Charles Lane.

CHARLES LANE,
The Murdered Messenger.

DETECTIVE THOMAS F. O'NEILL.

PATRICK KELLY, SERGEANT OF DETECTIVES.

BERTILLON OFFICER J. A. DUNDON.

Clockwise from upper left: Charles R.H. Ferrell, Charles Lane, J.A. Dundon, Patrick Kelly and Thomas F. O'Neill. (PC)

Foster's biographer, Alonzo B. Shaw, later wrote that Foster received a call from Captain John A. Russell at about 12:30 a.m. Russell said, "Tom, hurry to the Union Station, an express messenger has been found murdered in his car on its arrival at the station." Foster quickly dressed, leaving "his underwear to put on some other time on his return, that is, if he ever returned."

Within a few minutes, Foster was questioning conductor Taylor, but "so far as the murder of the express messenger was concerned, he was as dumb as the engine that pulled the train." He learned from the fireman, however, that he had seen two men behind the water tank when the train stopped at Plain City.

Foster consulted with an assistant, "Richards,"[5] whom Captain Russell had sent from police headquarters, and they decided to turn the train around and retrace the route it had taken from Plain City. He was looking for the money bags that had been removed from the safe. The first stop was Marble Cliff, where they got off to begin their search, only to watch helplessly as the train continued on to Plain City without them. Consequently, the two investigators spent the rest of the night walking back to headquarters. It was 7:00 a.m. by the time they reached their destination.

Although Foster was in rather bad humor by this time, Police Superintendent William Pitt Tyler encouraged the two detectives to set off for Plain City in a horse and buggy. They reached the town at 11:30 a.m., ate lunch and then Foster told Richards to trail behind him because he was going to find a "clew."

Mama's in the Furnace, the Thing and More

Foster went in search of a man he knew named Barney Smiley who operated a livery and a small hotel. He found Smiley at work in the barn and asked him whether any strangers had stayed at his hotel last night. Smiley said "there was a young fellow came off the midnight train," stayed the night and left on the morning train for Columbus just after breakfast. Although the man was not carrying any luggage, he did have a package that he sent by express.

At the hotel, Smiley showed Foster the room the stranger had occupied and pointed out which of two beds he had slept in. The detective thoroughly searched the first bed but found nothing. Turning his attention to the second, he quickly located a gun hidden between the mattress and the springs. It was later determined that this was the one that had been used to kill Lane.

Foster proceeded to interview Smiley and his wife to obtain a detailed description of the young man, including his height, weight, eye and hair color and the clothes he was wearing. He had developed a theory that the man who committed the crime was, in all likelihood, an express messenger himself. He noted that the robber had apparently been permitted to ride in the express car, even though this was against company policy. Furthermore, Lane had been shot as he was washing up, which was the practice whenever he was nearing his destination.

Since the robber had fewer than twenty minutes to accomplish the deed, Foster felt certain he knew what was in the bags he stole from having previously handled them. He did not have time to open them but made off with $1,600 in cash and $2,400 in checks. He also fired six shots from his own revolver before firing two more from Lane's gun into the hapless

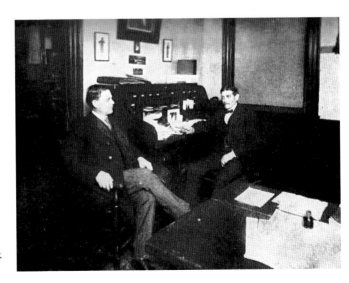

Thomas E. Foster, the "Buckeye Detective," is seen at right in this photograph taken from his biography. (PC)

messenger's body. Foster believed his suspect had boarded the express car at Urbana and disembarked at Plain City, fifteen miles away.

Next, Foster paid a visit to the Adams Express Company office in Columbus, where he learned they had fired an express messenger named Ross Ferrill (aka Rosslyn H. Ferrell) two months earlier. The company file included a detailed description of Ferrill that matched that provided by the Smileys.

On Sunday morning, Foster and two police officers went in search of Ferrill's boardinghouse. He had moved around some since being discharged from his job, but they finally located his current residence. Unfortunately, he had already set out that morning before they arrived. Foster spoke with a man who claimed to know Ferrill and identified the gun he had found hidden under the mattress in Plain City. He told Foster that on Friday night—the night of the murder—Ferrill had not been in his room.

Tipped off that Ferrill had a lady friend in the eastern part of Columbus, the trio set out to locate her. The two officers arrived before Foster and spotted Ferrill and his friend sitting on the porch of the girl's home. They easily took him into custody. A patrol wagon was called, and they hauled Ferrill to police headquarters, where the detectives "sweated" him until he confessed to having murdered Lane.

Ferrill explained that he had mailed a bundle with the money sacks and envelopes to a fictitious name in order to deflect suspicion from himself. On Saturday, he had traveled about Columbus, paying off his debts and making payments on furniture. He confessed he was engaged to be married to a young lady, Miss Costlow, from a highly respected family and had represented himself as being a person of means. He had no idea that Adams Express planned to fire him and that his "run" was going to be assigned to another man.

"I studied the matter over and over, and the longer I thought of the unfair treatment of the express company, the more I was determined to get money from that company, regardless of the chance I must take to get it," Ferrill related. "I said to myself, 'I will get the money.'" His intent from the beginning was to kill Lane, and in preparation, he had cleaned and oiled his gun.

Ferrill had given his fiancée $750, telling her he had withdrawn it from his bank account. The two of them went on a shopping spree, purchasing an expensive suit for him to wear at their wedding, which was to take place on Thursday. On Sunday afternoon, they attended church, and later he read aloud to her the newspaper accounts of the murder and robbery.

When Foster questioned why he got off the train at Plain City instead of at Union Station, he did not have an answer. He said simply that he got off, not caring much what became of him.

Mama's in the Furnace, the Thing and More

Now, Foster's account is somewhat at a variance with that provided by Colonel Frank H. Ward, crime reporter for the *Columbus Star*. According to Ward, Police Inspector Thomas G. Baron assigned detectives Thomas F. O'Neill and James A. Dundon to investigate.

They immediately concluded that the crime had been committed by a novice because a professional would have tossed the "through" safe and the bullion from the car to be retrieved by an accomplice. They also felt that only a novice would have committed an unnecessary murder.

Finally, they deduced that it must have been an inside job because the packages containing valuables that were removed from the safe were not opened in the car. Therefore, the person who stole them must have known what they contained.

In Ward's account, it was O'Neill and Dundon who arranged for the train's engine to retrace the route at 2:00 a.m. Saturday. They do not mention Foster, but they were not alone. Other detectives were dropped off every few miles along the right of way to hire rigs and visit farms bordering the railroad tracks to learn if the farmers had observed anything unusual.

A passenger had flagged down the train with a burning newspaper at Marble Cliff. The man was Edward E. Holton, who was returning from the country club. Holton reported that he had not seen anyone get off the train when he got on. Ward wrote that O'Neill and Dundon (again, no mention of Foster) went to the Smiley Hotel, woke up the proprietor and asked him if anyone had registered after 10:15 p.m. the previous evening. He told them no one had. So they rented a rig and drove on to Milford Center.

Tried for the murder of Charles Lane, Ferrill was convicted and sentenced to die in the electric chair. On the day before his scheduled execution, he was visited by his brothers, George, William and Charles, of Steubenville. He had already bid farewell to Miss Costlow when she drove to the jail in a closed carriage for the last time at 2:00 a.m. on February 28, 1901.

On March 1, 1901, Ferrill was escorted to the death house by Father Kelly of the Catholic Church, who had previously administered the last rites. Ferrill walked directly to the platform and sat down in the electric chair. He was joined by Father O'Reilly, and the two priests stood in front of him. Asked by Warden Darby whether he had any last words, he replied, "I have nothing to say." Earlier, he had said, "I know it is hard to die, but I am not afraid. I would rather be executed than stay here for life. I hope to meet you all in heaven."

Ferrill's body was shipped home to Steubenville in a purple coffin per his request.

CHAPTER 5

MURDER IN SELLSVILLE

In the late nineteenth century, the Sells brothers of Columbus—Lewis, Ephraim, Allen and Peter—operated one of the largest circuses in the country. Originally, the Sells Brothers Circus had its winter quarters on Main Street between Grand and Washington Avenues. However, as the city grew, the brothers moved their operation across the Olentangy River to an unincorporated area bounded by Lane Avenue, West Fifth Avenue and North Star Road. This community of circus folk came to be known as Sellsville.

Now, Sellsville had not been completely uninhabited prior to the arrival of the circus. Gypsies were known to camp there during the summers, hobos had a "jungle" near the Hocking Valley Railroad tracks and some older black residents were former slaves who had escaped to freedom via the Underground Railroad. As a result, the community's school on Virginia Avenue near Chambers Road was known as the Polkadot School because the student enrollment was equally divided between black and white children.

Then there were the animals. They escaped from the circus with alarming frequency. Longtime residents of Sellsville reported encounters with polar bears, elephants, monkeys, etc. Sellsville historian Carl Weisheimer wrote many years later, "It seems this area was sort of a dodgem of escaped circus animals."

Columnist John Schweitzer summed it up this way: "Sellsville was an accumulation of truck gardens, orchards, slaughterhouses, saloons, blacksmith shops, mills and the circus grounds. The Sells Brothers Circus was a big-time show with 332 workingmen and 64 entertainers. The large menagerie included 18 elephants, pumas, black panthers, hyenas, antelope,

Mama's in the Furnace, the Thing and More

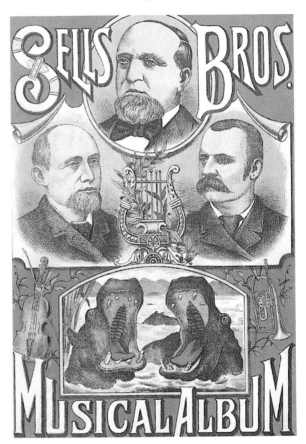

Although they initially entered the circus business during the Civil War, it wasn't until 1871 that the Sells Brothers Circus was officially founded. (PC)

lions, tigers, leopards, zebras, bears, rhinoceroses, sea lions, monkeys, hippopotamuses and 245 horses for pulling wagons and performing."

Sellsville was, basically, one big happy family until August 16, 1908. Although the last surviving Sells brother, Lewis, had sold the circus four years earlier following the death of Peter, there were still remnants of the area's show business past. Many of the residents continued to have ties to the circus. And in August, many of them were on the road.

The Niederlanders (or Niedlanders)—Arthur, age thirty-four, and his wife, Louise, nineteen—owned a modest grocery store that, this time of the year, catered to the farmers and the African Americans who had settled beyond the woods. They had married two years earlier when he met her in Vinton County and brought her back to Sellsville following a whirlwind courtship. She was his second wife; his notoriously bad temper had led his first wife to divorce him.

Louise loved living in Sellsville. She never tired of hearing the circus people talk of their adventures, watching them rehearse their acts or visiting the caged animals in the enormous heated barns. She envied and shared vicariously in their nomadic existence. But there is no evidence she was anything but faithful to her husband.

At about eight o'clock on a pleasant Saturday evening, Arthur and Louise decided to cross the river to Columbus to do some shopping. Locking up their store, they set off by foot for the corner of Grandview and West First Avenue, about a mile away. They caught the Arlington trolley car, which took them into the city. Three hours later, they returned to the same corner, carrying their purchases.

The Niederlanders lived and worked in the two-story wood frame building that stood flush with King Avenue, about a mile from the Olentangy River. On the first floor was a large room that served as the store. Behind it was a smaller room that contained a stairway leading to their second-floor residence.

As Colonel Frank H. Ward later described it, "From a small landing at the top of the flight of stairs a window opens to the south. Opposite, a door leads into the sitting room. Behind the sitting room is the kitchen, and back of that a small bedroom, eight by 10 feet, in which Arthur and his wife sleep. In front of the sitting room is the parlor, and beyond that the guest bed chamber."

Arthur's parents, Mr. and Mrs. John Niederlander, lived immediately east of the store and, next to them, his brother, Edward, and his wife. Whatever transpired that night, the family members apparently did not see or hear it.

Early on Sunday morning, ten-year-old Everett Kimbro was walking down King Avenue toward the Olentangy River, eager to do some fishing. He pulled up short when he discovered a dead dog lying in the dusty road about thirty feet from the Niederlanders' store. As he inched closer to the carcass to see whether he recognized it, something else caught his eye. The foot of a nearly naked young woman was protruding from a nearby ditch.

At that moment, Arthur's mother happened to be out in front of her house cutting flowers. Looking up, she saw a terrified youth running toward her. He led the elderly woman back to the ditch to view his discovery. She saw at once that it was the body of her daughter-in-law, Louise, clad only in a peach-colored chemise. Another source says that Kimbro first alerted Mr. and Mrs. Samuel Bird before running to tell others and that Mrs. Niederlander was attracted by the crowd forming in front of the store.

Mrs. Niederlander immediately rushed to the store to notify Arthur, only to find that the glass had been broken out of one of the large double doors.

Mama's in the Furnace, the Thing and More

Reaching through the opening, she unlocked the door, passed through the store and climbed the back stairway to her son's room. The door was already ajar. Inside, she could see "a heap of crimson-stained bedclothes." Lying dead beneath them was her son.

Following the 8:00 a.m. roll call at the police station in Columbus, Detective Chief James Dundon[6] grabbed six plainclothes men to accompany him to the crime scene: Charles A. Landacre, John W. Dorgan, John H. Porter, Mark Nolan, George H. Gaston and John H. Jones. He felt that Gaston and Jones might be of particular value because they were his top two "negro" officers and the crime scene was close to the African American settlement.

Franklin County coroner Joseph A. Murphy was called in to examine the bodies. He saw that both of the victims had been shot at close range; there were powder burns on Arthur's shirt and a yellow-edged hole in Louise's chemise. However, they had also both been stabbed in the breast with a thin, narrow-bladed knife. Clearly, their assailant wanted to make sure they were dead.

During a departmental reorganization in 1904, James A. Dundon was appointed to the new position of chief of detectives. (PC)

Investigators suspected that Mrs. Niederlander may have been awake, reading in bed, because an open book lay facedown beside a lamp on the table next to her side of the bed. Her husband was probably asleep at her side. In all likelihood, he was slain first. A single bullet had been fired through his chest and came out his back, burrowing into the mattress.

Although Arthur may have died instantly, the murderer made certain by stabbing him twice in the heart. So violent were the knife thrusts that the springs at the head of the bed were dislodged and dropped to the floor. Furthermore, there was a long gash in the plaster at the side of the bed, suggesting a third stab had gone astray and hit the wall.

At some point, Louise had attempted to flee. She made it through the living room and kitchen and down the stairs to the store before she was overtaken. Evidently, the assailant seized her, threw her to the floor and choked her into unconsciousness, as the twenty fingerprints on her throat and the bluish cast to her face attested. She then was shot, the bullet passing through her body from armpit to armpit. Finally, she was stabbed twice in the chest, but neither thrust reached her heart. An attempt had been made to clean up the pool of blood in the center of the store, although no rag or mop was ever found.

For some reason, the lifeless body of Louise was then carried outside and dumped in the ditch, where it surely would be discovered. Or was it? Sellsville resident Willie Patterson claimed that as he had approached the grocery that morning he heard several shots and screams. Immediately afterward, Mrs. Niederlander broke through the glass of the front door and ran up the street.

Owing to neighborhood gossip, Patterson jumped to the conclusion that she had possibly shot her husband and had been shot by her father-in-law in return. He turned around and started running east, briefly hiding himself in a culvert before cutting through a field to his cousin's house on North Star Road to tell what he had seen. Apparently, Patterson's account was not believed.

Half of a painter's extension ladder, eighteen feet long, was leaning against the back of the building. It was just under the window that opened from the second-floor stairway landing. This appeared to be the method by which the murderer entered the building, although the detectives were puzzled by the lack of dusty footprints on the ladder. At that time of year, there was dust everywhere in the streets and fields.

Detective Gaston was immediately sent home to fetch his bloodhounds, Duke and Jake, so they could backtrack from the foot of the ladder. After sorting through the many scents left by footprints of the investigators and curious onlookers, the hounds set off through the fields and woods to the Fifth Avenue crossing of the Hocking Valley Railroad. Then they lost the trail.

Mama's in the Furnace, the Thing and More

A woman who lived near the tracks told Gaston she had heard two men talking during the night—foreigners, probably Latin—but after the train rolled by, she heard them no more.

Back at the house, the detectives searched high and low for the murder weapons, a .38-caliber (or, possibly, a .48-caliber) revolver and a stiletto-like knife. All they found was a heavy soldering iron under the Niederlanders' bed. They concluded it had been placed there for protection, possibly because the couple was expecting an attack.

The evidence of a robbery was inconclusive. Arthur had a single dollar in his clothing, and the store's money drawer was sitting on top of the counter. It contained a few pennies. A gold pin worn by Louise was missing, but not a watch she had borrowed from a neighbor.

If Louise had heard someone in the store and went downstairs to investigate, a burglar (or burglars) might have killed her, but it seemed unlikely they would have then proceeded upstairs to the bedroom to murder Arthur, as well. Besides, the culprit seemed to have entered on the second-floor level.

Without an obvious motive, the investigation was going nowhere. Then it was learned that a man from Louise's hometown was living in Sellsville. Not only that, but he had been reared by Louise's father in the same house with Louise. And they were the same age. After Louise moved to Sellsville with Arthur, the man roomed with them for a while before leaving after an argument with Arthur over money.

The young man moved in with Mr. and Mrs. Niederlander, Arthur's parents, and his bedroom window was just twenty-five feet from that of the slain couple. Naturally, he was arrested and transported to the police station for questioning. On the night of the murders, he said that he and a friend, Sam Beaverly (or Reveley), who boarded with Edward Niederlander, Arthur's brother, had gone to Columbus and did not return until 12:30 a.m. They walked home from the Grandview and First Avenue trolley stop to King Avenue but did not hear or see anything suspicious.

Curious as to whether there was any evidence of a love affair between Louise and the young man, detectives traveled to Vinton County to interview their former neighbors and also questioned their closest neighbors in Sellsville. The results were negative.

However, Beaverly, who lived but two houses away, claimed that just after he retired for the night, he heard Louise scream, "I'll kill you," followed by a gunshot and the sound of a body hitting the floor. In his opinion, his "buddy" had killed the couple.

Anna Bird, an African American woman, said she heard the scream, too, but no shot. Her husband, Samuel, heard neither. One neighbor was certain the woman cried, "Oh, Hoy!" (the name of a neighbor) while another said it was, "Oh, Arthur!"

A popular theory among their Sellsville neighbors was that Louise had murdered Arthur and then was slain, in turn, by some third party as she tried to flee the scene. Why? They didn't know. Who? They didn't know that, either. But the couple had frequently fought, and once Louise had threatened Arthur with a revolver, although no weapon was found.

For a time, suspicion fell on a black man, Charles Ross, who resided in Arlington but five years earlier had been sentenced to fourteen months in prison for burglarizing the Niederlanders' store. Although he was building a house in Sellsville and had vowed to get even with them after his release, he had an airtight alibi for the night in question. It seems he had fallen asleep on the High Street trolley at 1:30 a.m. and had ridden it four times from one end to the other. He had been awakened at 5:00 and rode the Arlington car home.

J.W. Hoy reported that he had been awakened about 1:00 a.m., first by the return of his son from Columbus and then by what he thought was a rock tossed against the window. Suspecting it might be a drunk, he had armed himself with a gun and gone outside, where he hid in some bushes. He then heard a woman scream. He started to walk toward the store when he heard a gunshot. His first impression was that it had come from inside the store—he had seen the flash reflected in the window—but he later admitted it could have been outside. By this time, his wife had come out onto the porch, too, and they were in agreement on one thing: there was no ladder leaning against the store at that time.

If what the Hoys said was true, that meant that the ladder might have been planted at the scene to divert attention elsewhere. In the long, matted grass at the foot of the ladder, the detectives found a carpenter's gouge or wood chisel, spattered with dried paint and putty. The blade of the gouge perfectly fit the jimmy marks on the window. It seemed unlikely that someone using the ladder as a "plant" would go to this much trouble.

The detectives determined that they had the upper half of an extension ladder, so they set about finding the bottom half. They did not have to look very far. It was in a shed owned by a painter, Pardon Newkirk, who lived not far away on Morning Avenue and West Third. His son, John, twenty-six, positively identified the upper half of the ladder, but Pardon denied it was his. Neither of them claimed the gouge.

Mama's in the Furnace, the Thing and More

As it turned out, the gouge or wood chisel was of the type used at the Excelsior Buggy Body & Seat Manufacturing Company on West Fifth Avenue, where Pardon had worked until two days before the crime. As a result, he was arrested.

This time, the neighbors had more to offer. It was learned that a couple of weeks earlier, Pardon's wife had been bitten on the hand by Arthur's bulldog as she shopped at his store. The dog[7] had been put to death immediately, but the Newkirks were not satisfied. On the day before the murders, Pardon Newkirk had visited the office of Assistant Prosecutor Reed Game and demanded that he have Arthur arrested. Game told him to take it up with a lawyer. Pardon had, purportedly, threatened to kill the storekeeper.

Detective Gaston, subsequently, went undercover as a prisoner and had himself locked up with John Newkirk. He found the man was eager to talk about the charges against him, maintaining he had spent much of the night alone at a switchman's shanty at the Fifth Avenue crossing of the Hocking Valley Railroad. Gaston felt the only way John Newkirk could have committed the murders was if he were crazy. After all, what sane man would leave a ladder and a wood chisel behind that could be tied directly to him and then try to use such a lame alibi?

Pardon Newkirk insisted that his son did not own a revolver. He had taken it from him six weeks earlier and given it to a man named Morehouse. Morehouse confirmed he still had the weapon in his possession.

Nevertheless, as weeks went by, John Newkirk remained under lock and key while all of the other suspects were released. He soon began to mumble about seeing "goblins and specters" before shrieking that they were after him. "See them!" he repeated, "they are chasing me. There they come right behind me, but I won't let them catch me."

Wagonman Al Welker finally filed a lunacy complaint against Newkirk, which led to an evaluation by Drs. George T. Harding and Robert Tarbell. They found that he was, in fact, insane, and Probate Judge Samuel L. Black had him committed to the Columbus State Hospital for the Insane.

After seventeen years, John Newkirk was discharged from the hospital as "improved." But whether he was guilty of murdering Arthur and Louise Niederlander was never determined.

CHAPTER 6

IN A LONELY PLACE

Morgan Station, named for William Morgan (a prominent landowner), was once a stop on the interurban line running southwest out of Columbus just beyond the village of Orient. In 1898, the state established a custodial farm for "feeble-minded" males on 1,672 acres at Morgan Station, with housing for three hundred inmates. They worked the farm along with some fifty employees.

Not far away, "behind the fields and the woods," lay a 118-acre farm owned by forty-seven-year-old Fannie F. Hagelgans. Her house was a "magnificent," ten-room structure overlooking Big Darby Creek. Alonzo B. Shaw wrote, "A lonelier spot might have been selected for human beings to inhabit, but not in that part of the country."

Shaw described Fannie Hagelgans as a "strange woman" who surrounded herself with luxury. Although she would entertain friends on occasion, she spent much of her time alone with her books, music, pictures and artificial flowers. She also had dogs, cats and livestock. She distrusted banks and was widely believed to have kept her money stashed in her home.

A tireless worker and an astute businesswoman, Fannie was never considered stingy and had no known enemies. Yet, on the night of February 26, 1909, or thereabouts, she was murdered. On March 5, Fannie was found lying on a couch in the room where she often slept, a bullet hole in her left temple. A revolver was clutched in her left hand, giving the impression that she had taken her own life.

For more than a week before Fannie's corpse was discovered, people noticed that her farm was being neglected. On Thursday, two duck hunters, Philip Johnson and D.R. McKinley, were surprised to find her cattle in the

Mama's in the Furnace, the Thing and More

The Pickaway County home of Fannie Hagelgans, an eccentric spinster who dabbled in the occult. (PC)

cornfield because she was such a careful farmer. Finally, on Friday, a party of her neighbors led by storekeeper Will P. Sprouse went to her house and broke through the front door. Their worst fears were immediately confirmed when the stench of death enveloped them.

A few men stood guard outside the house while Fannie's brother, Henry Hagelgans, was notified. The deputy coroner was summoned from Columbus, but when he realized Fannie's house was located just outside his jurisdiction in Pickaway County, he left without viewing the body.

At first, the police were convinced that the .32-caliber revolver found clenched in Fannie's left hand belonged to her slayer. Henry Canter, described variously as the dead woman's tenant and a sawmill operator from near Orient, often helped her with the butchering. He identified two other revolvers found in the house as belonging to her but insisted he had never seen the fatal weapon before.

However, Canter also gave an explanation for the dried mud found in the gun: after it had been used to kill a hog on December 27, it had been

accidentally dropped in a posthole (presumably by him). When he retrieved it, he noticed there was mud clogging the barrel.

The time of death was established as Friday evening, February 26, between 5:30 and 6:00 p.m. Why? Because Fannie ate at 5:30 every evening, and her supper had been barely touched. Also, her livestock had not been fed on Friday; her custom was to do so immediately after finishing supper. Every door and window, save one, was locked from the inside. Presumably, the murderer had gone out the window, dropping ten feet to the ground.

On a stand by Fannie's bedside was a typewritten horoscope, dated two years earlier and signed by Professor Leo Arnige. He warned her to "beware on behalf of a friend who wishes to marry you" and that 1909 would be a particularly dangerous year. However, he also suggested Fannie would soon be married, a prospect that the spinster hopefully shared with her closest friend.

Despite her interest in the occult, Fannie was regarded as a "friend of churches" who read her Bible and "kept a good supply of religious periodicals." She did not, however, subscribe to any particular faith, and some recalled that her father had once fired a shotgun at heaven because he was angry with God over the annual spring flooding. Her funeral, held at the Methodist church in Harrisburg, was the largest the village had ever witnessed. She was then buried nine miles away in Mount Sterling next to her parents.

Another mystery was the fact that Fannie's feet had been tied together with a "rough cloth bandage." Dr. G.W. Helmick explained, though, that the German residents of the area believed that a cord knotted three times (as this one was) would ward off headaches. It was tied too loosely and was of insufficient strength to restrain her. There was also a medicine bottle at her side.

Three motives were offered early on by the investigators: first, that Fannie had been murdered by a spurned suitor; second, that it was a robbery (the previous year she had fired three bullets out a window at some prowlers); and third, that she had been attacked by a feeble-minded or imbecilic inmate from the nearby state institution. The coroner quickly dismissed the last possibility because he felt the nature of the crime showed that a "sane" mind was behind it.

One theory was that she was taking a nap between supper and stock-feeding time when she was attacked. She threw up her left arm to ward off a blow that struck her on the elbow and the head, as evidenced by contusions. The blow rendered her unconscious, at which time her assailant pulled out a pistol and fired a single bullet into her brain. He then took one of three pistols that she kept on a table—the one that had one discharged cartridge—and wrapped

her hand around it. Finally, so he wouldn't have to look at her any longer, he covered her with three blankets and tucked them in around her. Later, it was decided that the contusions were simply the result of decomposition.

Coroner Dudley Courtright theorized at the inquest held in Circleville that the person who murdered Fannie Hagelgans might have remained in the house with her corpse for up to three days. During that period, he believed the culprit or culprits searched her house for hidden money and other valuables. But only a gold watch and a small locket studded with diamonds were known to be missing. A pocketbook found under the couch contained only a few pennies. Fannie's larder, which was usually full, was empty, and all the eggs had been eaten—Fannie's friends swore she never ate eggs under any circumstances.

If that was the case, then the villain was there when eleven-year-old William "Lonnie" England stopped by on Saturday morning and when William Ziegenspeck and a lady friend called on her Sunday afternoon. After peeking in the windows and seeing nothing, they left. A little earlier, Isaac Clinger, another neighbor, hadn't found anyone home when he came by in search of work. Her killer was there while the state farm employees worked in the nearby fields. And he was there when Will Leech came by every evening to feed the stock because he saw that they were being neglected.

Three years earlier, Frank Kohler, a Dutchman, had spent a winter working for Sophia Clouse Gehring—Fannie's friend and confidante—and her elder sister on their farm, four miles from Fannie's home. "We always feared him, and were glad when he left," she told a reporter. "Fannie feared him, too." She stated that he had a woman friend in Columbus whom he visited and who received his mail for him.

Wednesday night before the murder, Kohler got off the interurban car at Orient, according to Conductor Russell Hill. Then on Friday morning, February 26, Lonnie went to the Hagelgans house to borrow an auger to tap a maple sugar tree. He saw the man in the kitchen of the house, and he told the boy that she had "gone to Columbus to spend a week or so with a sick relative." The door to the room was closed. Kohler gave him the auger and told him to leave it on the porch if he was not there the next day when he returned it. Lonnie did so. (The boy waited several days before volunteering this information because he was afraid his father would punish him for going over to the Hagelgans house.)

Monday morning, March 1, Lonnie saw Kohler again, wearing a long overcoat and walking briskly through the woods from the direction of the murdered woman's home to Orient. A torn apron was found along this

path on Saturday, and Mrs. Gehring identified it as one of Fannie's. Peter Zapp of Columbus reported that he had dined with Fannie at her home on February 5. At both dinner and supper, they were joined by Kohler, whom he described as a "surly, vicious man, with little or nothing to say." Fannie had mentioned to Zapp that her will provided for her pallbearers to receive fifty dollars each and jokingly asked if he would be one of them.

Dr. Frank McKinley thought he saw Kohler in Harrisburg on Monday morning. A Dave Toulson said he saw "someone who looked like him" near Orient the same morning. Someone else saw him in a Circleville saloon, while another reported he boarded a Columbus-bound interurban car at 5:20 p.m. The police believed Kohler was hiding out in Columbus.

In secret testimony, Sophia Gehring revealed to authorities the places where Fannie customarily hid her money and other valuable papers. She had previously stated that Fannie told back her in early December: "Sophia, I'm afraid of that man [Kohler]; I don't want him to come back anymore." The woman had spent all Tuesday night in Fannie's barn, waiting for her friend to return home, not realizing she was already dead.

The bond between Sophia and Fannie went back twenty years, to when Fannie was betrothed to Sophia's son. It continued when the son died before the marriage could take place. Since then, Fannie's chief amusement was making paper and wax flowers. She also kept a fully decorated Christmas tree in her bedroom year round. A room on the second floor of her home was never opened following her father's death—maintained as a "death chamber" according to an old German custom.

Fannie's brother, Henry, who had discovered the horrifically decomposed body after being alerted by neighbors that she hadn't been seen for weeks, was understandably distraught. He especially regretted that they had quarreled two years earlier and had not spoken or hardly even seen each other since.

An article in the March 16, 1909 issues of the *Columbus Citizen* quoted G.F. Brown, head of the National Secret Service Company, that "if Frank Kohler will walk into my office I will guarantee that I can vindicate him of the charge of murdering Miss Hagelgans." But he didn't and he wasn't. In the meantime, the Pickaway County commissioners withdrew their offer of a $300 reward because the county treasury had been "seriously depleted since the place went 'dry'." Henry Hagelgans had also withdrawn his $500 reward, but that was because he had hired Thomas Foster, "The Buckeye Detective," to solve the crime.

Like previous investigators, Foster was certain Fannie's death had been staged. "Her notion was to live—she enjoyed life." Foster believed the

Mama's in the Furnace, the Thing and More

Unlucky in love, Fannie was known to keep large sums of cash hidden in her home because of her distrust for banks. (PC)

furnishings of her home testified to that. There were a pianola, pictures and books—he was especially drawn to the books.

The detective singled out two volumes in particular. One was *The Devil of To-day*, dedicated "To all brave and courageous souls who are seeking to destroy the works of the devil." The other was *The Egyptian Secrets of Albertus Magnus or White and Black Art for Man and Beast*. In the latter, Foster found that many pages had been marked, including a protective spell so "that nobody may hurt you and how to be secured against all assailants." Apparently, Fannie was afraid of someone.

From the tracks outside, Foster determined that Fannie had been slain outside and then carried into the house by her assailant(s). The revolver had, he believed, been dropped in the mud at that point. Afterward, they took their time roaming through the house, helping themselves to whatever valuables they found, and even paused to fix themselves a meal before they departed.

Frank Kohler (or Frank Coaltz, as he is called by Foster's biographer) was the focus of Foster's investigation from the beginning.[8] He had been seen on the day of the murder asking for directions to Commercial Point. However, he did not go there but instead went to Columbus and returned to Morgan Station that night. The morning after the murder, he stopped for breakfast some two miles south of the Hagelgans farm. When asked why his face was black, he attributed it to the fact that he had been shoveling coal in Columbus. However, his hands were not black, and his face had not been black when he got off the streetcar at Morgan Station the previous evening.

Even before the murder of Fannie Hagelgans, Kohler was a man of mystery. He made frequent trips to Columbus, but nobody knew where he went or what he did there. He also was prone to appear and disappear without any explanation. After the morning of March 1, he was never seen again.

On March 17, 1909, a man who registered under the name "Frank Miller," of Indianapolis, Indiana, boarded the steamship *Breslau* in Baltimore

Detective Thomas E. Foster, the "Buckeye Detective," was hired by Henry Hagelgans to investigate his sister's murder. (PC)

Harbor, bound for Germany. Suspecting that Miller might be Kohler, Foster pursued him. As he wrote in a letter to Henry Hagelgans, "The waiter on the Breslau, steerage department, who served all his meals during the voyage, gave me a complete description of Kohler, better than I could have given myself; so full and complete that there can be no doubt."

Foster further reported that he had learned that Kohler had visited Fannie shortly before her death to tell her he had married and that his wife was in Germany to look after an estate he was to inherit. He confirmed that a woman named Miller had taken a ship for Bremen in October 25, 1908, and had come to believe that Miller was, in fact, Kohler's true name.

The detective noted that Fannie had also been visited by a "sweetheart" a few days prior to her murder. The man claimed to be a minister of the gospel from New York. However, when he was suddenly called home to preside over a funeral, Fannie drove him to Mount Sterling one night and did not return until two o'clock in the morning. He had apparently caught the 11:00 p.m. train. Foster speculated as to whether the man was actually a preacher or the possibility that Kohler had introduced them.

After completing his investigations in Baltimore, Foster stated that he would be going to New York City before returning to Columbus. He informed Henry that he was willing to sail for Germany to continue investigating Kohler, but that would depend upon whether Henry would be willing to finance his trip. Foster had put together several clues that he believed would provide him with the location of Kohler's former home in Germany.

In addition, Foster had located a widow who lived on the Philadelphia Road, outside of Baltimore. She told him that Frank Kohler had worked for her husband in 1904. Then, following her husband's death, Kohler had returned in the spring of 1905 and insisted on staying with her. The widow described Kohler as a "sullen, mean kind of fellow" who would not stay away until she prevailed upon a Baltimore detective to drive him off.

Kohler left the Baltimore area and turned up not long afterward at the Hagelgans home. He soon went to work on the state farm that adjoined her property. The widow and the detective were certain it was the same man. Unfortunately, Foster was never able to pursue him to Germany, and Fannie's murder remains unsolved. But even if Kohler were to blame, many suspected he had assistance. And since no one else in the vicinity of Morgan Station was known to have left in the days following the murder, then his accomplice was likely to still be living among them.

CHAPTER 7

INSANITY COMES QUIETLY TO THE STRUCTURED MIND[9]

On Tuesday, February 19, 1918, Forest Bigelow, a forty-two-year-old agent for the Ohio National Life Insurance Company, deacon at the Indianola Church of Christ, member of the chancel choir and former professional bicycle racer, not to mention husband and father, revealed to the citizens of Columbus and the world that he was, also, quite mad. At about 5:20 a.m., Forest took a hatchet he had spent hours sharpening until not a speck of rust remained and proceeded to murder his wife, Lena, and seven-year-old daughter, Annabelle.

Both were found dead in the same bed. Mrs. Bigelow, thirty-four, had been struck twice, one blow to the left side of her neck and the other directly across the throat, very nearly beheading her. Little Annabelle came close to being decapitated, as well.

The Bigelows lived on East Norwich Avenue in a brick, two-story building containing five small row houses numbered 78 to 86. They occupied 86 on the eastern end of the building, facing south. Still carrying the bloody axe, Forest stepped out onto the porch they shared with 84 and turned left. Crossing the street, he walked a block east to 121 East Norwich Avenue, the residence of his mother-in-law. It was a wood-framed double and larger than his own home, which he deeply resented.

Using a pair of wire cutters he had thought to bring with him just for this purpose, Forest cut the telephone lines to his mother-in-law's residence as well as 119, the adjoining one. He then rang the doorbell.

Jumping out of bed, Mrs. Hazel Steele, age thirty-eight, answered the door. She had the misfortune of being the madman's sister-in-law. Forest told her, "Annabelle is sick and I want to use your telephone." Forcing his way

Mama's in the Furnace, the Thing and More

Right: Forest Bigelow was a talented athlete who competed in several sports, including professional bicycle racing. (UCH)

Below: The Bigelow family lived in a brick, five-unit apartment building just north of The Ohio State University campus on Norwich Avenue. (PC)

into the house, he attacked Hazel in the dining room, crushing her face and nearly cutting off her head as she attempted to fight back.

Hearing the commotion, Mrs. Sallie Cruit, sixty-six, Hazel's mother, slipped out of bed and rushed downstairs, where Forest was waiting for her. Twice he struck the woman in the neck with his axe, knocking her to the floor. Then Forest turned and walked out. Somehow, Sallie was able to rise to her feet. Staggering toward the front door, she was met by her next-door neighbor, U.L. Conway.

"I heard a scream and rushed to find out what it was about," Conway later told investigators. "I thought it might be a burglar." By the time he got out of bed and downstairs to investigate, Forest was gone. "I rang the door bell. Mrs. Cruit opened the door. I saw the hole in her head. Her face and clothing were covered with blood." When he asked Sallie what had happened, "She pointed to the body of her daughter and went back to it."

Conway saw there was nothing he could do to help Hazel or Sallie, so he tried to call a doctor, but the telephone was dead. He went back to his own home to make the call. After discovering that his line had been cut, too, he ran down to the corner to find a working telephone. He placed a call to a doctor and the city police.

When Officers Maurice Clark and Glenn Kemp arrived at the scene, Mrs. Steele's four-year-old son, Frederick, was kneeling over his mother's lifeless

Forest's mother-in-law lived in a double on Norwich Avenue, just a block away from his own residence. (PC)

body, trying to get her to speak. He had been upstairs when the attack began but may have witnessed part of it. There is reason to believe Forest spared his life because of his friendship with the boy's father. Frederick was covered in blood, having attempted to staunch the bleeding with a handkerchief. Nearby, his grandmother was lying on the floor unconscious.

Retracing the murderer's steps, the officers carefully entered the Bigelow home by the front door, passing a note Forest had tacked to the outer door instructing the newsboy to "Stop the paper." In the upstairs bedroom, they found Forest lying across the bodies of his wife and daughter. A Colt .45 revolver was in his right hand. As they approached him, the hand holding the gun slipped down, apparently from the vibrations.

Thinking for a moment that Forest might still be alive, Clark and Kemp trained their guns on him and came close to firing. However, almost immediately they realized that he was either dead or unconscious. A quick examination confirmed that Forest had shot himself in the head, as he had planned.

Forest Bigelow had been a resident of Columbus for nearly a quarter of a century. He had moved here from his home in rural Madison County. One of his forefathers, Isaac Bigelow, had laid out the town of Westminster, which later became Plain City. His body was interred in the Bigelow Cemetery with other pioneering members of the family.

Originally, Forest was a professional bicycle racer and won numerous medals. But he also was suspended from competitive racing by the League of American Wheelmen at least twice, the second time for continuing to compete while on suspension. Afterward, he took a job as a streetcar conductor on the Camp Chase line. When he later was hired to sell insurance, he proved to be quite competent and successful. He kept excellent records.

Forest and Lena R. Cruit had been married nine years. It was his second marriage and, by all accounts, a tempestuous one. Attorney Walter S. Page reported that Lena had consulted him about a divorce on September 20, 1915. A petition was drawn up on October 4 of the same year, but they apparently patched up their troubles four days later. However, on February 28, 1917, she had once again filed a petition for divorce. This case was never heard.

The couple had separated several times, and about two and a half years earlier, Lena had moved into the house on Norwich. Forest had recently joined her as they attempted to reconcile. Still, neighbors were aware that their domestic life was anything but happy. In particular, Forest was at odds with his mother-in-law, who had opposed the marriage from the start, and he had forbidden her to ever enter his home.

Six days before the murders, Lena had visited the office of Police Prosecutor John K. Kennedy and informed him that Forest had burned up some of her clothing. She felt her husband was insane. On Saturday night, Kennedy called on Forest and ordered him to report to municipal court on Tuesday afternoon at 2:30 p.m. to try to work out a solution to his domestic problems.

The extent to which Forest had preplanned this massacre was made clear by the written instructions he left behind. The clothes he wished to be buried in were arranged on a chair, along with a note naming the six men who should serve as his pallbearers. The note also identified six women he wanted to sing at his funeral, along with the hymns to use: "I Am Resolved No Longer to Linger" (page 278), "Amid the Trials Which I Must Meet" (page 389) and "Jesus, Meek and Gentle" (page 448). Forest also stipulated that Reverend Willard A. Guy should officiate.

Nearby was a confession Forest had paused to write after the slayings. It read: "I have killed Lena, Annabelle, Sally Cruit and Hazel. They will let me rest." It was signed "F. Bigelow." But he was wrong about Mrs. Cruit. She was still alive, albeit barely, and would survive.

Forest also left a note for his mother, who lived in Plumwood, Madison County, Ohio:

> *Mother keep the watch for Leon, also the piano. Sell the furniture and pay the expenses that is made and the insurance will put us away. We never did get along together, so bury us side by side. Lena's mother and sister put her up to everything, so made us very unpleasant, so we will quit together, so I will leave to my God what to do with us. Goodbye friends, brothers and sister, son and daughter, we are at rest now. Give mother the contents of the house and the Ford. I owe two months rent, due the 25th of February. Mother pay that. All other bills are paid. Mr. Randall and Mr. Clifford will you please help mother dispose of and adjust everything. You will find notes for collection, also some policies to lapse in my desk. Names, addresses, and when to collect all in good shape which will pay you for your trouble. You boys have treated me fine, goodbye. May God help you.*

Leon was Forest's son by his first wife. At the time, he was serving with the American Expeditionary Force in France. Forest's only other child—Annabelle's twin brother—had died at birth. The insurance policies were ones he had taken out with the Woodmen of the World, a fraternal benevolent association. E.C. Randall and A.L. Clifford worked

with Forest at the National Life Insurance Company, and perhaps he considered them friends.

Still another note turned up dated Monday at 11:45 a.m. It read: "Mother you can have the property at West Jefferson as long as you live—then it may be divided, share and share alike, to the children, Leon and Annabelle Bigelow and Edna M. Bigelow Hunt; or whichever one's are living at mother's death." Apparently, Forest had not originally intended to kill his daughter. Her fate may have been sealed when he found her in her mother's bed rather than her own.

Finally, there was a note asking that Mr. Cline, a grocer, be paid thirty-eight cents Forest owed him and that a lock he had borrowed from the Penn Feed Store be returned. He had no further use for it. Forest directed that an autographed Bible be given to a Jennie Edwards.

For three weeks prior to the murders, Forest had neither sung in the choir nor participated in any other activities at the Indianola Church of Christ. Then a week before the crime, he told Reverend Guy to remove his name from the church membership because he "did not want the church to be drawn in if anything should happen."

Lena told some of her neighbors that Forest had tossed all of her clothes into the backyard on Monday because he thought she had drunk all of the milk at breakfast. Similarly, he had accused her of disposing of some of his clothes.

On Monday evening, Forest had paid a visit to Clifford at 6:30 p.m., accompanied by Annabelle. He gave his co-worker a list of clients and some documents, saying he wanted him to have them. He then took out a small diamond ring and asked Clifford to loan him ten dollars for it. Although Clifford wrote him a check for the amount, he didn't want to accept the ring. Forest insisted. While they were talking, Lena called but hung up when Clifford handed the phone to Forest. Before he left the office, he spent some time at his desk, writing.

Sometime on Monday evening, Forest also called on his physician, Dr. J.O. Welch, to settle his account. After thanking the doctor for his services, he told him he was going away. Various other creditors were paid off and told he would not be seeing them again.

An estimated two thousand people, mostly women, attended the funeral of Lena R. Bigelow, Annabelle Bigelow and Hazel Steele on Thursday, February 21, 1918. Many were unable to gain admission to the Avondale United Brethren Church. Those who did waited up to an hour to view the bodies. Hazel's ex-husband, Lester Steele, who was stationed at Camp

Sheridan in Alabama, had asked that her funeral be delayed until he could attend, but his request was not honored.

The funeral oration was delivered by Reverend J.M. Wenrich, pastor of Hilltop Lutheran Church, who knew Lena and Hazel when they attended Sunday school in Stoutsville as children. Reverend A.J. Wagner, pastor of Wagner Memorial United Brethren Church, offered a prayer for Sallie Cruit, who was still recovering from her wounds at Protestant Hospital. Afterward, the three bodies were conveyed to Green Lawn Cemetery and placed in the Cruit family vault.

At nearly the same time, the funeral of Forest Bigelow was held at his mother's home, presumably in Plumwood, although the newspapers said West Jefferson. He was buried at Big Plain Cemetery. Contrary to Forest's wishes, he and his murdered wife were not buried side by side.

When interviewed by a reporter at the home of K.H. Johnson, his grandmother's next-door neighbor, little Frederick was quoted as saying, "Her head just swinged around." He was referring to Mrs. Cruit's attempt to lift his mother. He was later placed with Mrs. Marion Cupp, sister of Mrs. Cruit.

In the annals of axe murders, this one can boast neither the celebrity of the Lizzie Borden affair (two deaths in 1892) nor the carnage of the Villisca incident (eight deaths in 1912). Neither is there any mystery as to who did it. Forest Bigelow was just an ordinary man—and quite insane.

CHAPTER 8

THE THING

At 9:50 p.m. on Friday, September 9, 1921, a Columbus, Urbana and Western traction car left Columbus heading west to the city's Storage Dam (renamed Griggs Dam in 1922). It was manned by motorman Elmer Myers, age thirty-one, and conductor Russell Crute, twenty-five. They were friends and fellow veterans of the "The Great War."

During the first decade of the twentieth century, Ohio created the largest interurban system in the nation, connecting all towns with populations of at least ten thousand and many smaller ones in between. Completed by 1908, the system was gone by 1939, replaced by the rapid growth in automobile ownership.

The streetcars or trolleys ran on standard-gauge railroad tracks and were powered by traction motors fed by electric lines running overhead. A trolley pole attached to the wire would cause it to "sing" when the car sped along the rails, bell clanging and whistle blowing.

When they reached the Dublin Avenue crossing of the Big Four Railroad (Pittsburgh, Cincinnati, Chicago and St. Louis Railway Co.), Crute jumped down from the car, crossed the intersecting tracks and grabbed the derail lever. There were lonelier spots along the line, but standing in the darkness, the conductor could not help but feel uneasy. There had recently been a spate of attacks on his co-workers.

All at once, a monstrous form rose up from the underbrush and approached Crute. It was hideous. The upper half resembled the shell of a turtle, and two white-rimmed eyes glared at him from a vaguely human head. Although he was a veteran of the world war, nothing Crute had ever seen scared him as much as this creature.

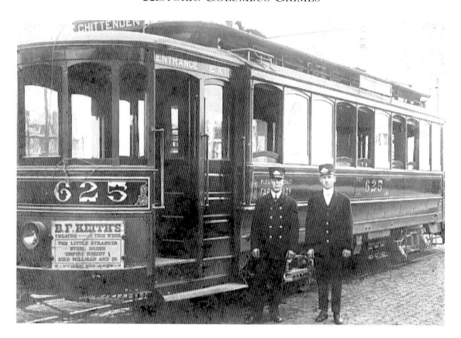

The interurban system made use of trolleys such as the one shown in this 1904 photograph of the Chittenden Avenue car. (CML)

When the monster barked, "Stick 'em up," Crute threw off his coat and prepared to tangle with it. He did not intend to give up the fifty dollars in receipts he had in his pocket without a fight. Back on the traction car, Myers could not see what was occurring, but he sensed his co-worker was in trouble when he saw him remove his coat. Seizing the controller handle, he jumped from the car to go to Crute's aid.

Mrs. A.G. Waterman and her daughter, Edna, passengers in the car, saw the flashes from the barrel and heard five distinct gunshots. Two of them struck Crute and Myers in their left hips. While Crute collapsed into a clump of weeds, Myers stumbled back to the car, where the passengers helped him climb aboard.

Bleeding badly, Myers told them, "They've shot my buddy. He's back there in the weeds. Somebody go help him." No one was inclined to do so. Although he was in no condition to operate the car, Myers was able to tell a passenger how to get it running, and he proceeded to drive it a mile west to the Municipal Light Plant.

A call went out to Sheriff Frank L. Holycross, and two ambulances were dispatched. One conveyed Myers to Mount Carmel Hospital. The other went to the scene of the crime, where Crute was found unconscious and near

death. He was taken to Protestant Hospital (later known as White Cross), where little hope was held out for his recovery. His coat, which contained the receipts he had sought to protect, was missing.

Although a bloodhound owned by Lester B. Marsh was brought to the scene, the dog was unable to pick up a scent. The police didn't even know what type of "thing" they were dealing with.

Because both bullets had taken an upward course through the men's hips, investigators thought they may have actually been shot by an accomplice who was down the hill from the man who committed the robbery.

On Saturday morning, Myers was able to give his account from his hospital bed:

> *I stopped the car to the east of the Big Four tracks for Conductor Crute to cross over them and throw the derail switch, which operates from that side. I noticed nothing unusual until I saw Crute stop with a peculiar gesture. He partially raised his hands, and I thought that he had run across a live wire. Then he grabbed the lapels of his coat, and I thought of a hold-up, although I saw no one but him. Crute turned around, and I thought he said something to me, so I left the car and started down the right side of the track toward him.*
>
> *When I reached the Big Four tracks, I stepped into the rays of the traction car's headlight. Just then Crute yelled, "Look out, buddy, look out," and at the same time I heard four to five shots in rapid succession. I think the first one struck me and I staggered around, and finally fell on the Big Four tracks. I didn't see Crute after he yelled at me, nor do I remember much about what happened then, although I saw a figure start from the weeds at the northeast corner of the track intersection and run towards Columbus along the Railroad track.*

Nevertheless, suspicion quickly fell on "a lone negro" who had been committing crimes in the area recently. On Saturday, Sheriff Holycross traveled to Springfield to question two African American men who had been nabbed by authorities there after having been seen on the Big Four freight train No. 95 shortly after the shootings. The men—Joe Thomas and Frank Bennet—were released after Holycross calculated that they could not have left the train, committed the crime and then rejoined it in the time available.

Crute, meanwhile, succumbed to his wound on Sunday and was buried on Tuesday. He left behind a widow, mother and two sisters. Myers was not told of his friend's death because of his own precarious condition.

"The Thing" costume fabricated by Henry Nitschke out of newspaper was crude but effective, especially in the darkness. (SW)

Soon, a $2,000 reward was offered for the apprehension of "the Thing." Half was contributed by the Columbus Railway, Power and Light Company, one-fourth by the Columbus, Urbana and Western line and the remaining quarter by prosecuting attorney John R. King from the "furtherance of justice" fund.

At the time, police records showed that the city had fifty-nine unsolved murders during the past five years. There had been convictions in twenty-eight others. The slaying of Conductor Crute was the fourth crime of its type in the past six months, and all of them remained unsolved.

Four of Police Chief Henry French's best detectives were assigned to work the case—James Creedon, John Spencer, George H. Gaston and John H. Jones.[10] They began their inquiry in the neighborhood where the crime had been committed. When they arrived at Henderson Tire and Rubber Company on Goodale Street, they learned that there was an employee—thirty-two-year-old Henry Nitschke (alias Robert Franklin or Franklyn)—who bragged that he had witnessed the holdup.

Mama's in the Furnace, the Thing and More

Nitschke, who worked the night shift, was brought into police headquarters for questioning. His fingerprints and Bertillion measurements were taken by Inspector Thomas A. Scully. However, Scully was unable to find any criminal charges against him. Scully did notice, though, that Nitschke used a very pungent hair oil.

Under questioning, Nitschke explained that he roomed with Angelo Cordesco at 1017 John Street, which was right next to the railroad tracks. On the night of the crime, he was walking along the tracks on his way to work when he heard five gunshots, and then "the Thing" rushed past him in the darkness. Since Nitchske's statement made him a material witness, the police decided to hold him pending further developments in the investigation.

On Sunday morning, two days after the robbery, detectives found Crute's coat four hundred yards from where he had been shot in a field east of the Big Four tracks. His tickets and other company property were still in his pockets, but the receipts were missing. Not far away were a cape made out of a September 6 edition of a Columbus newspaper, painted black, and a mask fashioned out of a paper bag. The cape had a hole cut in it like a poncho and had been sewn on the sides with black thread. The mask had holes for the eyes, mouth and nose, was daubed with black paint and had white circles around the eyes.

Scully was called to the station to examine the cape for fingerprints. He found none. However, he quickly recognized a familiar smell—the odor of hair tonic—Nitschke's hair tonic. He quickly sent for the suspect but learned that Lieutenant Claude McNeil had released him, thinking the detectives had finished their questioning.

The detectives rushed to his apartment on John Street, only to find that he was not there. What they did find, though, helped to build their circumstantial case against him. In his room were white enamel paint and lampblack of the type brushed on the costume. They also found the pieces of the newspaper that had been discarded, black sewing thread and the cutout shapes from the mask.

However, Detective Creedon saved the best for last, as he handed Scully a half-filled bottle of hair tonic and said, "Take a whiff of that!" It was the same odor he had detected on the cape and Nitschke. Mrs. Angelo Coresco added that a week earlier Franklin had borrowed a spool of black thread and a needle from her sewing basket.

Unfortunately, the only thing missing from their case was Nitschke. The detectives established that on the night of the murder, he was supposed to report for work at 10:00 p.m. but had clocked in at 1:19 a.m. The murder

had occurred at 9:50 p.m. They also found that the paint and the enamel had been taken from his employer's stock and that the paper bag was of the type used in the factory.

Furthermore, the night watchman at the factory reported that he had lost a .32-caliber revolver with four bullets in it—the same caliber of the slug taken from Crute's body.

Realizing that the police were onto him, Nitschke had quit his job without even bothering to collect the twelve dollars that was still owed him. On Tuesday, he was accidentally apprehended by a railroad detective in the Norfolk and Western yards, east of town, as he was about to board a freight train for Cleveland.

Since Crute had succumbed to his wound, the charge against Nitschke was first-degree murder. At police headquarters, Scully outlined the case they had against the man and asked him how he would vote if he were on the jury. Nitschke readily conceded that he would vote to convict but then added, "But if I am convicted, I want a stone on my grave marked, 'An innocent man killed by the state of Ohio.'"[11]

On November 20, 1921, in the courtroom of Common Pleas judge Robert P. Duncan, Nitschke faced a jury of his peers. It was trumpeted as the strongest case of circumstantial evidence ever assembled by the Columbus police. Surprisingly, Nitschke's lawyers told the jury, "Either Nitschke is guilty of a heinous crime and should go to the electric chair, or he should be acquitted. We submit that the state has not proved his guilt." They felt there was reasonable doubt regarding their client's guilt.

The jury, however, found him guilty of murder in the first degree but with a recommendation of mercy. Nitschke was sentenced to imprisonment for life because the jury struck a compromise, feeling there was insufficient evidence to take his life.

CHAPTER 9

MAMA'S IN THE FURNACE

On an otherwise unremarkable Monday in November, Mrs. Addie Sheatsley, a few hours after serving lunch to her husband and four children, crawled into the coal furnace of her Bexley home and shut the door behind her. She was fifty years old, the wife of Reverend Clarence V. Sheatsley, a compassionate friend, an immaculate housekeeper and, as far as anyone knew, quite normal.

In the opinion of Coroner Joseph A. Murphy, Mrs. Sheatsley must have had the presence of mind to tie a string or cord to the inner lining of the furnace door in order to pull it shut once she was inside the narrow compartment. It would have been tricky but, theoretically, possible. The evidence, of course, would have been consumed by the flames, along with much of Mrs. Sheatsley.

The Sheatsley family, consisting of Mrs. Sheatsley and her husband, also age fifty, sons Milton, twenty, and Clarence Jr., seventeen, and daughters Elisabeth, fourteen, and Alice, ten, resided in the parsonage of Christ Evangelical Lutheran Church in the fashionable Columbus suburb of Bexley. All indications are that they were respected members of the community.

Then on November 17, 1924, everything about their lives was thrown into question as evidence mounted that the Sheatsley household was anything but normal.

Bexley, named for a town in England, had been formed in 1908 when the upscale Bullitt Park neighborhood (established in 1889) was combined with the mostly Lutheran community of Pleasant Ridge surrounding Capital University and Trinity Lutheran Seminary. As pastor of the major Lutheran church, Reverend Sheatsley occupied an extremely high-profile position.

The Reverend Clarence V. Sheatsley was a key figure in the history of the Evangelical Lutheran Church in Ohio. (PC)

At 3:00 a.m., Elisabeth, hearing her mother moaning, went to her bedroom to investigate. Slipping into bed beside her mother, she later recalled her saying just before she fell asleep, "Elisabeth, your father will never preach a better sermon than he did last night." The topic had been "Paradise Regained."

After the family ate lunch together, Elisabeth and Alice left for school. It was 12:30 p.m. Milton departed at 1:15 p.m. for classes at nearby Capital University, where he played football and basketball. Fifteen minutes later, Reverend Sheatsley drove off to perform a few errands. Clarence Jr. was the last to leave at 1:45 p.m., returning to high school and leaving his mother alone in the house.

Directly across the street from the parsonage, two men repairing a porch saw Mrs. Sheatsley walk by an upstairs window several times. Then at 1:47 p.m., she leaned out a window to shake dirt from a rug. At 2:30 p.m., C.O. Strader entered the house through the kitchen door to deliver some bread. No one had answered his knock, so he left the bread on the table and departed.

Only fifteen minutes later, E.E. Bridewesser, a divinity student, dropped by the parsonage with the proofs for the Sunday school program. The window to the cellar was partially open, and he thought he heard someone stoking the furnace.

In consideration of this timeline, the detectives believed that Mrs. Sheatsley, either voluntarily or by force, entered the furnace between 2:45 and 3:15 p.m.

Reverend Sheatsley told the police he had originally intended to go out rabbit hunting on Monday but changed his plans because his wife was fretting over some trivial matters. Instead, he left the house at 1:30 p.m. to drive to a bank four miles away, where he cashed a check for twenty dollars. Investigators calculated that he arrived at the bank no later than 1:55 because it closed at 2:00 p.m. and only two additional checks were cashed after his.

Mama's in the Furnace, the Thing and More

Next, Reverend Sheatsley stopped at the clothing store adjoining the bank, where he purchased a green velour hat. He then continued on to Mercy Hospital in the south end of Columbus to visit with Miss Helen Roess, twenty, a member of his congregation who was a patient there.

Leaving the hospital, the pastor drove to the home of Reverend F.D. Mechling on Southwood Avenue, only a short distance away, where he learned from Mrs. Mechling that her husband was not home. At this point, he returned to Bexley and visited with another ailing congregant, Mrs. C.W. Holtzman, before heading home.

Reverend Sheatsley reached the parsonage about 4:30 p.m. He was met by his children, who complained of a strange odor that permeated the house. He thought it might be carbolic acid. He asked if any of them had done anything to the furnace, and Alice said that Milton had adjusted the draft. One of his daughters mentioned that their mother was not at home, but since she had not taken her cloak, he assumed she was visiting a neighbor.

When the children asked what they were going to have for dinner, Reverend Sheatsley decided to walk to a nearby grocery store. Elisabeth went with him. Upon their return, he saw extremely black smoke belching from their chimney and smelled a sickening odor. Hurrying into the house, he entered the kitchen, dropped his purchases on the table and rushed down into the cellar.

Peering into the furnace, Reverend Sheatsley thought he could see some bones, pieces of jewelry and a wedding ring. But he wasn't sure. So he summoned Professor Simon A. Singer, his next-door neighbor, to take a look. The two of them were in agreement: the furnace definitely contained a skeleton.

As Professor Singer went home to call the police, Reverend Sheatsley entered the library where his children were assembled. "Mama's in the furnace," he said.

Later, when questioned as to why the children had not visibly reacted to his statement, Reverend Sheatsley explained that he had spent years schooling them to be masters of their emotions. Apparently, this training applied even when informed that their mother had been partially incinerated in the cellar of their home.

Perhaps this also explains some of their other behaviors. For example, when Clarence Jr. came home from school at 3:30 p.m., he detected a strange odor and headed down into the cellar to check it out. Opening the door of the furnace, he thought he saw his mother "standing" on the glowing coals. His reaction was to go back upstairs to his room and lie down on his bed for a while before going outside to play football. He told investigators he wanted someone else to make the discovery.

When asked his opinion of why Clarence Jr. reacted in this way, Reverend Sheatsley replied: "Clarence probably saw the form in the furnace, but his heart told him, 'It can't possibly be mother.' There is a possibility that he was excited when he made the statement. You know how a boy is."

As it turned out, Clarence Jr. wasn't the only one who took a peek into the furnace. Arriving home shortly before Clarence, Alice and Elisabeth found Milton already there. Together, the three of them went into the cellar to investigate the awful smell. Alice said what they saw in the furnace looked like burning rabbit skins and paper. Milton said he didn't notice anything out of the ordinary. They then went back upstairs to discuss what they would have for supper.

At 4:50 p.m., the Bexley police received a call from Professor Singer, treasurer of Capital University, who told them what had transpired in the Sheatsley home. Realizing a case such as this was beyond the resources of his small force, Mayor Stephen Ludwig immediately called Chief of Detectives William G. "Shelly" Shellenbarger of the Columbus Police Department for assistance.

By the time Detectives Clell Cox and Harry Carson arrived on the scene at 5:45 p.m., Coroner Murphy was already in attendance. Incredibly, the body of Mrs. Sheatsley was still ablaze in the coal furnace. An hour had

Detective Chief William G. Shellenbarger is the large man standing one step below and to the right of President Theodore Roosevelt. (CML)

passed since Reverend Sheatsley had made the gruesome discovery, yet it had not occurred to anyone to attempt to put the fire out. The detectives immediately closed the drafts and doused the firebox with water so they could recover whatever remained of the unfortunate woman.

Mrs. Sheatsley was five feet tall and weighed 108 pounds. She apparently entered the furnace feet first, passing through the opening of the double doors, which was just over forty-four inches square. In order to close the doors behind her, she would have had to jerk the lining of one door into the lining of the other. The firebox in which Clarence Jr. had seen his mother standing measured twenty-six inches across.

Much of Addie Sheatsley's body below the diaphragm had been partially cremated. Sifting through the ashes, the detectives found portions of the hip and thighbones, a skull, arms, heart, lungs, liver and kidneys. A dentist was able to positively identify her false teeth, and a daughter confirmed that the jewelry was her mother's.

The detectives also checked for fingerprints, closely scrutinizing three on one hot-air duct and one on another. The latter seemed to be from blood. However, all the prints proved to be those of family members. A bottle of carbolic acid was also reported missing from the medicine cabinet; the family insisted it had been there on Sunday.

Although Reverend Sheatsley initially denied that his wife could have killed herself, a day later he announced he had changed his mind. He had been swayed by the assertion of some furnace men that it was physically possible for a woman of her size to crawl into the furnace. He also suggested that a woman of his wife's age (which was also his age) "might" become violently insane without warning,

And, finally, he said he had personal knowledge acquired during eight months in India (he had authored the 1921 book *Our Mission Field in India*) that people could become insensitive to pain through extreme fanaticism, particularly religious fanaticism. So was he suggesting that his wife was a religious fanatic? He didn't say.

Chief Shellenbarger arranged for a woman of Addie's size and weight to crawl into the furnace of his own home, which was identical to the one in the parsonage. He also poured a bottle of carbolic acid into the actual furnace, but it did not produce any detectable odor either inside or outside the house. (Strangely, the missing bottle of carbolic acid reappeared in the medicine cabinet a week after Mrs. Sheatsley's death.)

Mrs. Gladys Redelfs, wife of Reverend Lambert Redelfs, a Lutheran pastor in Lithopolis, seventeen miles south of town, showed up at police

headquarters and claimed that she had visited Addie on the day of her death, a fact that had gone unmentioned by Reverend Sheatsley and his children. According to Mrs. Redelfs, she arrived about 12:30 p.m. to deliver some Christmas cards Addie had purchased from her and was admitted by Alice. Mrs. Sheatsley invited her to stay for lunch, but she declined. She said she saw Clarence and his father in the sitting room poring over some mail. In her opinion, her friend seemed quite normal.

A chemist and a pathologist examined the charred lungs of Mrs. Sheatsley for the presence of carbon monoxide hemoglobin, which would be expected if she had been alive when she entered the furnace and breathed in the poisonous fumes. They also examined her esophagus for carbolic acid. To further test this theory, they burned two guinea pigs alive in the same furnace and then checked their blood. They found it contained high levels of carbon monoxide. The blood was "literally saturated with carbon monoxide."

The chemist, C.F. Long, and the pathologist, H.M. Brundage, concurred: "Mrs. Sheatsley did not breathe after her body entered the furnace; therefore, death existed at the time of the introduction of her body into the furnace." In fact, there was a complete absence of soot or carbon particles in her throat.

Questioned by authorities for six and a half hours, Reverend Sheatsley was able to convince them that he had nothing to do with her death. In fact, the police considered the possibility that a "tramp" may have committed the foul deed. Apparently, "a mysterious beggar" called at several homes in the neighborhood on the day Addie died. He asked for clothing and also that he be allowed to warm himself by the furnace.

Late Tuesday, a detective brought in a blood-splattered overcoat from a north side dry cleaning shop that was "scorched down the front and one of the cuffs appeared to have been singed." The man who left it was a stranger to the store owner and claimed he had obtained the coat from a woman on the east side. He dropped it off on Monday, the day of the incident.

Another woman who lived about five blocks away reported that an unknown youth had entered her cellar from an outside entrance and then attempted to gain entrance to the house from an inside door. It was locked, so he fled out the cellar door. She said she was home alone and became frightened when she heard a noise and discovered the outside door was fastened from the inside.

After considering the evidence, the coroner rendered a verdict of suicide. He reached this conclusion based on the following observations: 1) There were no signs of disorder in the house nor evidence that a violent act had been committed there; 2) The act of placing a body into the furnace would have been extremely difficult and could not have been accomplished without

dismemberment; and 3) It was relatively easy for someone of her size to enter the furnace voluntarily.

Coroner Murphy[12] further stated: "It is plain that the lady entered the furnace by the first opening—the upper door—taking hold of the door frame, putting her feet in first, then the rest of her body, head and hands last." He cited Clarence Jr.'s testimony that "when he opened the furnace door he saw his mother standing up in the furnace. And this is reasonable to believe. There was no room in the bowl for the body to lie in, but as the fuel was higher on the west side, the feet on the east, the body was in a crouching position as the feet were destroyed, allowing the body to swing into the firebox, where it was found as has been described."

As far as the opinion of Long and Brundage was concerned, Murphy asserted:

> *The manner of her death was an immediate asphyxiation, caused probably by soot or other irritants striking the glottis (opening of the larynx), causing reflex spasm of the vocal chords of the glottis, thus causing complete closure of the glottis for a time sufficient to produce death, as in choking—in the same matter a large portion of food, or external violence, would act. Monoxide gas, or smoke or dust, would not be found in the lungs.*

On Thursday, a funeral for Mrs. Sheatsley was held in her hometown of Paris, a small village outside Canton, Ohio. She was the daughter of Henry Sponseller. The family was accompanied by Detective Carson and remained with relatives for several days afterward. Meanwhile, members of the Capital University football team stood guard outside the parsonage.

After the coroner's verdict, life returned to normal (whatever that meant) for the Sheatsley family. Reverend Sheatsley continued as pastor of Christ Evangelical Lutheran Church until shortly after his marriage in May 1929 to Rosa E. Stukey, a Bexley widow, when he was promoted to the post of secretary of the board of Lutheran foreign missions. He passed away on January 19, 1943. His children all graduated from Capital University. Clarence Jr. was hired to coach football at Colby College ("The Mules") in Maine. One daughter married, the other became a teacher and Milton remained in Columbus the rest of his life. He died on July 18, 1998.

When Reverend Sheatsley returned to the pulpit two weeks after the incident for the first time since the tragedy, he told a crowd of students and faculty that "we could never have cleared our skirts of the suspicion of the foulest crimes, in our family, by the grace of God, had we not been living as becometh Christians."[13]

CHAPTER 10

BEAUTY AND THE BRAIN

Seven days were given over to jury selection. After 107 potential jurors were interviewed, seat number 13 was assigned to Mrs. Betty Cassady, the last and the only female member of the jury. (Another woman was disqualified for engaging in an unauthorized conversation with a defense attorney.)

Betty admittedly was surprised to be picked because she was totally ignorant of the case. She had quit reading crime news five years earlier when the newspapers reported that a woman's body had been discovered in the furnace of her home. Nevertheless, she felt she could set aside her canning and other domestic duties for a couple of weeks to help ensure justice was served.

That was how Mrs. Betty Cassady became a participant in the most sensational trial ever to take place in the city of Columbus. Dr. James Howard Snook, professor of veterinary medicine, inventor of the "Snook hook" (a surgical instrument) and Olympic gold medalist, stood accused of having murdered Theora K. Hix.

On June 14, 1929, the body of the twenty-five-year-old coed was found by two sixteen-year-old boys—Paul Krumlauf and Milton Miller—near the New York Central Rifle Range off Fisher Road. Her head had been battered and her throat cut, exposing the jugular vein. A broken key ring lay nearby. Among the scattered keys were two for an automobile and one for a door.

Beatrice and Alice Bustin had already filed a missing person report on their roommate, Theora Hix, a medical student. They shared an apartment at 1658 Neil Avenue. The sisters were summoned to identify the woman's body, which had been taken to the Glenn L. Myers Mortuary on Second Avenue.

Mama's in the Furnace, the Thing and More

In the opinion of Detective Chief William G. "Shelly" Shellenbarger, the murderer must have known something about anatomy from the way the jugular vein was severed. Suspicion first fell upon Marion Meyers, a graduate student who had dated Hix. Although Meyers was taken into custody on June 14, he proved to have a solid alibi. He was released after he, too, identified the body.

Through interviews with Theora's friends, the police learned she had frequently been seen riding in a blue coupe with a middle-aged man. Further questioning led to the tip that the middle-aged man was Professor James Howard Snook, a respected member of the faculty at The Ohio State University School of Veterinary Medicine. Three days after Theora died, Snook was arrested. He denied knowing anything about the murder. And he insisted he had sustained the cut on his right hand while working on his car, a blue Ford coupe.

Although Snook was undoubtedly a very intelligent man, he clearly did not have the makings of a criminal mastermind. As soon as his photograph appeared in the newspaper (the day after Theora's), Mrs. Margaret Smalley went to the police. She was the manager of several rental properties. "That couple has been renting a room from me as man and wife," she reported. "They registered as James Howard and wife. Mr. Howard said he was a

Dr. James Howard Snook was believed to be a faithful husband by his wife, Helen, although she had noticed a change after their daughter's birth. (CCJ)

salesman"—a salt salesman from Newark, a small town thirty-three miles east of Columbus.[11]

When allowed to see the suspect, Mrs. Smalley readily identified him as "James Howard"—not the most imaginative of aliases to be sure. Furthermore, the door key from the broken key ring, which had been identified as belonging to Theora, fit the door to the rented "love nest." And one of the auto keys fit Snook's blue Ford coupe.

The evidence began to pile up. There was blood on the upholstery of the automobile. A bloodstained pen knife and a ball-peen hammer were found at Snook's home. Notoriously cheap, he had attempted to wash the blood off the items rather than disposing of them.

Professor Snook could hardly deny he had been involved with Miss Hix, but he insisted he didn't kill her. Someone, he didn't know who, must have been using his car that night, because he was at home with his wife. However, Mrs. Snook would only say that she heard him come home; she didn't take note of the time.

Finally, after twenty-four hours of continuous questioning, Snook signed a confession (which he later repeated to two newspaper reporters). During the session, Prosecuting Attorney Jack Chester Jr. ordered Snook's attorney out of the room and then slapped the suspect, declaring, "The truth is not in you, sir!" That broke Snook's will, and he began talking freely. It was June 20. A week had transpired since that fateful night.

According to Snook, they had been driving to the rifle range where he frequently practiced his marksmanship. On the way, they had quarreled because he told Theora he was giving up the apartment at 24 Hubbard Avenue and breaking off their affair. She then demanded that he leave his wife and marry her. As the quarrel became more heated, she threatened to kill his wife and daughter and then attacked him, scratching at his face.

At that point, Snook said he grabbed a hammer from the car and struck the young woman repeatedly on the head until she became limp. He said he had previously given her a .41-caliber derringer and was fearful she was going to pull it on him. Now, uncertain whether she was dead, he took out his pen knife and cut her jugular vein to make certain.

Dumping the body facedown beside the road, Snook drove home, cleaned up, read the newspaper and had something to eat. He then went to bed, presumably to sleep.

Dr. Snook soon received a visit from Ohio State University president George Rightmire, who informed him that he was being dismissed from his job. Then, on June 21, he was indicted by the grand jury on a charge of first-degree murder.

Mama's in the Furnace, the Thing and More

The trial date was set for July 22. Common Pleas judge Henry L. Scarlett was determined to move the case forward as quickly as possible and only granted the defense a two-day delay when they filed a plea of insanity on behalf of their client.

In a trial that received nationwide coverage, Snook was defended by John F. Seidel and E.O. Ricketts of Columbus and Max Seyfert of Circleville. After Snook assured Seidel that he was innocent, the attorney issued a statement to the press: "If Dr. Snook killed that girl, I helped him do it." Snook testified: "Prosecutor Chester hit me on the side of the face two or three times on each side and knocked my glasses off. I think he said, 'Damn you, go ahead and tell the story; you've got to tell it; we know that you know more and must tell it.'"

Police Chief Harry French confirmed that the slapping incident took place.

To accommodate the forty members of the press covering the trial, three tables were placed across one end of the courtroom. Among the "star" reporters were James L. Killgallen of International News Service (whose daughter, Dorothy, would become famous in her own right), Morris DeHaven Tracy of United Press Association (author of the first book on Charles Lindbergh) and O.O. McIntyre, an Ohio native and one of the most popular columnists of the day.

Although Snook repudiated both his written and oral confessions, he otherwise admitted to the facts of the case through his testimony, save for severing Theora's jugular vein (as well as the carotid artery) and attempting to puncture her eardrum. In essence, Snook was claiming that by hitting her four or five times with a hammer he had "stunned" her, but he did not kill her.

However, the prosecution showed that Theora clearly was alive when her throat was cut and had subsequently bled out—her body was virtually drained of blood. Furthermore, the major wounds to her head were free of blood clots, suggesting she had actually been struck numerous times after she was already dead (a dozen times altogether). According to the prosecutor, Snook had previously admitted that he stuck the knife blade in her ear in an attempt to reach her brain but, when it proved to be too short, wound up cutting her throat.

For two weeks, the jury of twelve men and one woman, Mrs. Cassady, heard the testimony. Then, it took the jury less than thirty minutes to reach a verdict: guilty of murder in the first degree.

So what were they thinking? According to Betty Cassady (as told to Colonel Frank H. Ward), they were struck by two things: the intellectual superiority of Dr. Snook and the physical beauty of Theora Hix. Whether

Theora Hix was a medical student and Dr. Snook's lover, but was she also determined to destroy his marriage at any cost? (CCJ)

it was Betty or Colonel Ward speaking is unclear, but there was a belief that Snook should have been "exempt to temptations which to some others appeal so strongly." On the other hand, they imagined that Miss Hix was "a quiet, secretive girl who kept her love affairs to herself." Neither her roommate nor her parents, Dr. and Mrs. Melvin Hix of Bradenton, Florida, were aware she had a "boyfriend."

Throughout the jury selection, Snook sat in an orange-and-red-striped beach chair while recovering from a spinal tap. The fifty-year-old defendant exhibited little in the way of emotion or interest in the proceedings. But the readers of newspapers across the country were riveted by the shocking details that emerged concerning drug use and sordid sexual acts. Snook's attorneys did their best to paint Theora as a jazz age hussy.

Charles F. Long, the chemist who examined the contents of Theora's stomach, found a roast beef sandwich, some seeds, a small piece of brown paper, Spanish fly and cannabis indica. The last two were an aphrodisiac and a narcotic, respectively, and would have been readily available at the veterinary clinic. He also found traces of blood on Snook's clothing, his car, the knife and the hammer.

Mama's in the Furnace, the Thing and More

When it came time to offer a defense, Attorney E.O. Richards said there were only two propositions: self-defense or impaired mentality. He felt that the facts would show that both Snook and Hix were insane.

The jury was taken to see the $2.50-a-week, third-floor apartment in a "dingy" Hubbard Avenue rooming house. They noted it was within easy walking distance of Snook's home at 349 West Tenth Avenue. They then followed the same route Snook had driven that night from Twelfth Avenue and High Street and out Lane Avenue until they reached the shooting range near the Scioto River.

The jury also visited Snook's home, his office, Theora's former residence in Mack Hall and the garage that held the blue coupe automobile. They learned that the derringer he had given Theora was inoperable, something Snook, an expert shooter, admitted he knew.

Newspapermen James Fusco of Columbus and William C. Howells of Cleveland testified concerning Snook's confession. Howells quoted him as saying, "Ours wasn't a silly, damn fool affair. It was a temporary, pleasant arrangement. She was a good companion. We never had any thought of marrying; in fact, she said she wouldn't marry me on a bet."

Betty believed "every member of the jury was nauseated" by Snook's "cold-blooded" attitude toward his affair with Theora. Dr. Dean B. White, dean of the veterinary clinic, had to admit that despite his high regard for the defendant, he considered firing him because his work had begun to slip and he had heard rumors of his association with women other than his wife.

Snook had met Hix three years earlier when she was hired as a stenographer for the veterinary department. He had given her a ride home one rainy day a few days later. Theora shared details of her affairs with him, and he wrote her at least a dozen letters, signing them "Mabel." When she told him during the summer that her boyfriend had gone away, the door was open for Snook to become her lover, generally between the hours of 6:00 and 9:00 p.m.

In Betty Cassady's opinion, Snook might have escaped the death penalty had he said he loved Theora, claimed he killed her in the heat of passion or shown some signs of remorse. Instead, he took every opportunity to impugn her character and blacken her reputation. There was also a hint that this had not been his first affair.

Snook claimed Theora boasted she knew more about sex than he did and urged him to read up on the topic. She also told him that she and Marion Meyers had been fined twenty dollars after they were caught having sex by the river. She chided him that Meyers had been a better lover. When Snook drove the woman to the parking lot of Scioto Country Club to have sex, he

said Theora told him, "I would like to go someplace further where I can scream." This is what led him to drive to the rifle range.

When they attempted to have sex in his parked car, it did not go well. He suggested they should leave and mentioned he wanted to take his family to his mother's house for the weekend. This set Theora off. "Damn your mother," she screamed. "I don't care about your mother. Damn Mrs. Snook. I am going to kill her and get her out of the way."

After pausing in his testimony to remove his glasses and wipe the tears from his eyes, Snook continued with the biggest bombshell of the trial. In no uncertain terms, he went into explicit detail about how Theora opened his trousers and began to perform oral sex on him. The testimony was considered so shocking that the respectable newspapers wouldn't print it. However, those who wanted to know the sordid details could purchase a hastily printed booklet that was peddled on Columbus street corners (courtesy of an enterprising court stenographer).

Snook said Theora handled him so roughly that she inflicted unbearable pain. In order to make her stop, he "very nearly twisted her arm off," at which point she sat up and said, "Damn you, I will kill you, too." She then grabbed her purse and slid out of the car. Fearing she would shoot him with the (inoperable) derringer he had given her, Snook said, "I hit her once then. I hit her again and she slid right down on out on the ground and I followed her out. I got up behind her and I hit her once more with the hammer and she went down and her head hit against the running board of the machine, and that is all I can remember of hitting her."

When Chester questioned Snook as to why he had not mentioned this previously, he said "simply because I was ashamed of it, ashamed of any sex perversion because I never knew anyone that would do that before."[15]

At five feet, seven inches and 145 pounds, Hix purportedly had claimed she was confident she could defend herself against any comparable man. Clearly, Snook wasn't taking any chances.

In his final address to the jury, Seyfert said he was a small-town lawyer who preferred to speak from the heart rather than the brain. He then went on to say of Snook's wife, "There is no whiter color in the blossoms of April, the crescent moon, or mountain snow than that woman depicted when she walked into this room and when she kissed Snook and he returned the caress. I will ask you if Snook looked like a murderer and a criminal?"

For his part, Chester appealed to them: "When you go into that jury room I ask you to bring back a verdict that will tell those parents of Theora Hix sitting over there, that will tell the parents of all university students, that

Columbus, Ohio, and Ohio State University is a safe place for them to send these children, that they won't meet dirty dogs like that down here anymore."

Judging by the applause from the spectators, Chester had won the day. It took several minutes for Judge Scarlett to bring them under control.

When they retired to the jury room 3:57 p.m. on August 14, 1929, the first thing the thirteen of them did was pray—that they would pass the right judgment. Only eighteen minutes later, they returned to the jury box, and foreman C.S. Baird, a retired Groveport farmer, announced that they had found the defendant, Dr. James Howard Snook, guilty. The jury was dismissed, and Mrs. Cassady was free to return to her canning.

On the evening of February 28, 1930, Dr. Snook was put to death in the electric chair. In a pre-dawn ceremony conducted by Reverend Isaac Miller of the King Avenue Methodist Church, he was quickly buried in Green Lawn Cemetery under a stone marker that read: "James Howard"—the name he used when he rented his "love nest" on Hubbard Avenue.

CHAPTER 11

BLOOD BROTHERS

The .44-Caliber Killer, as he was initially dubbed by the press, took his first victim on July, 29, 1976. Donna Lauria was killed in a car just outside her apartment in New York City when a man came up to the car owned by her date, Jody Valenti, and began shooting as the couple said their goodnights. Between October 1976 and January 1977, three more couples were attacked. Four of the six victims survived; one, Joanne Lomino, was left permanently paralyzed; and one, Christine Freund, died.

On March 8, 1977, a coed, Virginia Voskerichian, was shot and killed while coming home from class at Barnard College. By April, the .44-Caliber Killer decided that he was tired of that name. Near the bodies of victims Valentina Suriani and Alexander Esau, he left a note and signed it with the name by which he is better known to history: "Son of Sam."

The last murder took place on July 31, 1977. Stacy Moskowitz died, and her boyfriend, Bobby Violante, was left almost completely blind.

The. 44-Caliber or Son of Sam murders made national headlines and brought the New York City Police Department to its knees for a full year. These events must have been fresh in the minds of police officers all over the country, particularly those in central Ohio, when a pair of brothers commenced their reign of terror as the .22-Caliber Killers just five months after Son of Sam ended his.

In the early morning of December 10, 1977, less than an hour after last call, Joyce Leah Vermillion, a barmaid, and her friend, Karen P. Dodrill, a factory worker, left Forker's Café, where Vermillion had just finished locking up. As they walked out the back door of the bar toward Dodrill's waiting car, the women undoubtedly felt there was safety in numbers, even if that number was only two.

Mama's in the Furnace, the Thing and More

Neither was a stranger to the late-night bar scene of Newark, Ohio, and as any barfly in her mid-thirties knows it's dangerous for a woman to be out by herself at night. It was probably for this reason that Dodrill met her friend after a late shift to drive her home. Unfortunately for Vermillion and Dodrill, on this particular winter night, two was not enough to protect them.

In what was later determined to be a murder and robbery, the women were peppered with .22-caliber shells from a distance of fewer than ten feet and left to die in the cold night air. Alerted by Larry L. Vermillion, who was concerned when his wife failed to return home, the police arrived at the scene sometime after 8:00 a.m. By then, the bodies of the women had frozen to the ground, surrounded in icy puddles of their own blood, the unlucky and innocent victims of a ruthless robbery. All the murderers stole were the women's purses and the night's receipts for the bar.

If the police in central Ohio hoped that the Forker's Murders, as the deaths of Vermillion and Dodrill were being called, were an isolated incident, that idea was quickly dispelled.

On February 12, 1978, the home of bar owner Robert "Mickey" McCann was broken into. The burglars used a crowbar to force their way in through a

The bloody trail began at Forker's Café in Newark and came to an end in the parking lot at the Great Southern Shopping Center in Columbus. (CPD)

door. Although McCann, fifty-five, was not home when the break-in occurred, the burglars did surprise his seventy-seven-year-old mother, Dorothy Marie. She was immediately shot three times in the head with a .22-caliber Stoeger-Luger. The thieves left her body where she fell, apparently not interested in her, and proceeded to search the house. They went so far as to rip paneling off the walls, probably looking for a hidden safe.

While his house was being ransacked, McCann and his go-go dancer girlfriend, twenty-six-year-old Christine Herdman, were pulling into the attached garage. Before he could even remove the keys from the ignition of his Cadillac, McCann watched his girlfriend get shot four times in and around the head. Turning his back to the killers, he then ran out of the garage, either to find help or as a means of self-preservation. He did not make it far.

McCann was shot twice in the back of the head, once under the chin, twice in the forehead and once in the back of the leg. He was then dragged back inside the garage, where his body and that of Herdman were stripped and searched.

According to the police, the killers took everything they could get their hands on, even the change in Herdman's purse. Not even the Cadillac made it out unscathed. A stray bullet had flattened a tire.

Like at the scene of the Forker's Murders almost two months earlier, the snow around the McCann house was littered with .22-caliber shell casings. Unlike Joyce Leah Vermillion and Karen P. Dodrill, Mickey McCann was not simply in the wrong place at the wrong time. As owner of Mickey's El Dorado, he managed to rack up a list of potential enemies as only a bar owner with questionable business practices could. He had been arrested eleven times for assault and three times for molestation. He had managed to avoid prosecution in every incident.

It seemed that no one—women especially—ever wanted to testify against him. There were also rumors that he was either in debt to some loan sharks for a large amount of money or that he was currently dealing with a group of Dayton mobsters who wanted to purchase the El Dorado. However, it was another rumor—that Mickey kept large sums of money, jewelry and maybe even cocaine in his home and on his person—that most likely led to the triple homicide that day.

On February 13, the bodies of Jenkins T. Jones, seventy-seven, and his four dogs were found in his Granville, Ohio home by his daughter, Doris, and her husband, Lucius Williams. The police found several .22-caliber shells on the front porch of the house. Bullets had shattered the glass of the door, and the area around the doorknob was broken out.

Mama's in the Furnace, the Thing and More

The Lewingdons were indiscriminate killers, shooting anything that crossed their path, including a number of dogs. (CCJ)

Inside, Jones lay facedown on the bedroom floor. He had been shot a total of six times. In the basement, two of his dogs had been shot to death. In a kennel behind the house, another two had been shot dead in their cages. As in the McCann murders, the house appeared ransacked, and it was difficult to determine what exactly had been taken. Also like Mickey McCann, Jenkins Jones made himself an easy victim. He was known locally as a bit of an eccentric who carried large amounts of cash with him at all times. He often paid cash for large and expensive farm machinery and was frequently seen around town spending money on younger women.

The similarities between the victims and the crimes were not lost on the Newark, Columbus and, now, Granville Police Departments.

Twenty-two days later, Reverend Jerry Fields, pastor of Berean Baptist Church, was moonlighting as a security guard at the Wigwam Club in Fairfield County when he was found dead at his post. The Wigwam was a private club owned by the influential Wolfe family, media magnates from Columbus. The property was a large compound surrounded by a high fence.

Fields's wallet had been stolen, as well as the gun he carried at work, and his body was surrounded by .22-caliber cartridges from the same $109, semiautomatic "junk gun" used in the earlier killings.

The reverend's billfold was later found on the side of Interstate 70. Fields's wife, Virginia, told the police he would not have had more than a few dollars in it. Fields was generally considered to be an honest family man. It now seemed that anyone, good or bad, rich or poor, could fall prey to the .22-Caliber Killers.

It would be another month before the unknown killers struck again, but the police were hardly sitting on their hands. As well as following up on numerous leads and tracking down every .22-caliber Stoeger-Luger in Licking, Muskingum and Franklin Counties, the police were dealing with a very troubling and very troubled young lady.

Claudia Yasko, twenty-two, was a go-go dancer with a history of mental illness. When she walked into the police station a few weeks after the McCann murders, confessed to the crimes and promised to help the police in their investigation, what she was actually doing was anything but helpful. After describing the crime scene in uncomfortably accurate detail, Claudia, her boyfriend, Deno Politis, a heroin addict, and Robert Navotney, a friend of Deno's, were all arrested and charged with the murders.

The two men subsequently passed lie-detector tests, and one was able to produce an ironclad alibi. Soon, the whole Yasko affair attracted the attention of *Playboy* magazine and the Playboy Foundation, which assigned two private investigators to the case.

However, on May 21, something happened that put the Yasko confession to rest for good. While Claudia and her two "accomplices" were still in custody, Jerry and Martha Martin were shot to death in their North Columbus home. It was obvious to everyone on the scene that the .22-Caliber Killers had struck again.

On what was to have been Martha's fifty-first birthday, her husband was shot through a window while lying on the sofa. The front door of her home was pried open, and she was shot in the throat. Again, the house had been thoroughly searched. Even Jerry's pockets were turned out. A $16,000 reward was now offered by local newspapers. There were many leads but no real suspects, and never any witnesses. Politis and Navotney were released, while Claudia Yasko checked into a psychiatric hospital after she left police custody.[16]

The case went cold for almost eight months.

Then, on December 4, 1978, Joseph Annick was working in his garage when he was shot to death and robbed of his wallet and credit cards. Originally, his death was not linked to the .22-caliber murders because a different gun was

used. It was not until six days later, a year after Joyce Leah Vermillion and Karen P. Dodrill were slain in Newark, that a real break in the case occurred.

Gary Lewingdon was arrested when a clerk at a South High Street Woolco store realized that he and his wife, Delaine, were trying to use Annick's stolen VISA card to purchase forty-five dollars' worth of toys. Confronted in the parking lot by an assistant manager, Gary was taken into custody immediately; Delaine was arrested later at their home. Without much coaxing, both told police everything they knew.

Gary's forty-two-year-old brother, Thaddeus, was also arrested. He did not resist. A search of their homes recovered both murder weapons, many rounds of .22-caliber ammunition and various valuables stolen from the homes of victims.

In his taped confession, Thaddeus recounted the events of each homicide in graphic detail. Gary was the brains of the operation, picking the victims and then planning the robbery/murders. The brothers would target people they heard about through friends or work. The primary motive was money, although the murder of Reverend Jerry Fields seems to have been more about curiosity. Fields surprised the Lewingdon brothers while they examined the grounds of the Wigwam Club. Had they thought about robbing the Wolfe family?

Gary was sentenced to eight consecutive life terms and was later transferred to the Lima State Hospital for the Criminally Insane. He attempted an escape in 1982, when he and another prisoner managed to saw through the bars of a window. Both were quickly apprehended.

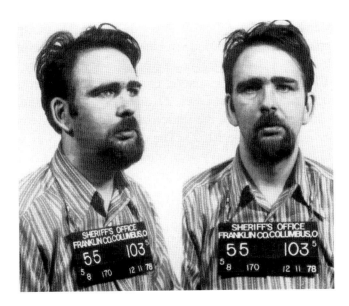

After Gary Lewingdon married a waitress who worked in a club owned by Robert "Mickey" McCann, he went on a yearlong murder spree. (FCS)

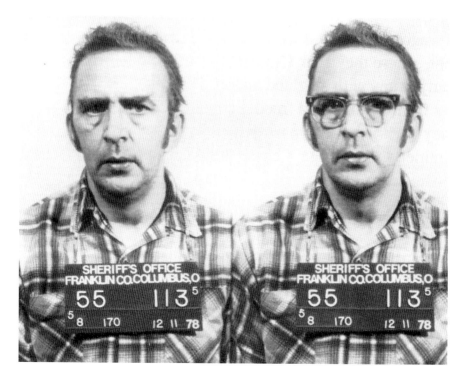

Although initially a willing participant, Thaddeus Lewingdon had a falling out with his brother following the murders of Jerry and Martha Martin. (FCS)

Thaddeus was sentenced to nine life terms. In 1989, at the age of fifty-two, he died in prison of lung cancer. Nine years later, Gary was denied parole. He died of heart failure in 2004, awaiting his next parole hearing in 2008. No one claimed his body, and Gary Lewingdon, one of the .22-Caliber Killers, responsible for no fewer than ten murders in central Ohio during 1977 and 1978, was buried in obscurity at the Ohio State Reformatory cemetery.

David Berkowitz, the .44-Caliber Killer, who confessed to six murders, has had at least three feature-length films made about him. His "fans" maintain an authorized website and, no doubt, are breathlessly awaiting the release of his promised memoir. Owing to his notoriety, several states enacted "Son of Sam" laws during the eighties to prevent convicted criminals such Berkowitz from capitalizing on their crimes. Nevertheless, serial killer memorabilia—autographs, paintings, poetry, etc.—remain a hot commodity.

The Lewingdons, by contrast, never attracted anywhere near the same level of national media attention but quietly spent the remainder of their years in Ohio prisons, far removed from the spotlight.

CHAPTER 12

HOW NOT TO WRITE A CRIME NOVEL

Jack Drummond wanted to be a crime writer in the worst way. And it wasn't enough just to write about crimes—he needed to commit them. That was the only way he felt he could know for sure how real crimes differed—if they did—from imagined ones.

"What right…have we to copy crime if we don't know it first hand?" Drummond wrote, anticipating the question he knew would be asked. More than thirty years later, many questions still remain.

After all, for fifty-five years, two months and four days, Drummond had led a crime-free life, at least as far as anyone knew. He didn't have a rap sheet. His fingerprints weren't on file with the FBI. His picture wasn't hanging in the post office. He had stolen a gun, though. That was the first step of his carefully plotted transformation from crime writer to crime writer *and* bank robber.

Drummond was a guy who had thought about crime a lot. In fact, he had written two crime novels. The first, *The Flight Instructor Murders*, was published by Exposition Press in 1977 under Drummond's nom de plume, George Redder. Based in Hicksville, New York, Exposition Press was one of the largest vanity publishers in the country. Drummond would have had to pony up a couple thousand dollars just to see his book in print. It is unlikely it was ever reviewed or stocked in any bookstores. If it sold any copies at all, it was probably to friends and associates who would have contacted the publisher from a list provided by the author.

Drummond's second novel, *The Murder at Madison Square*, remained unpublished. Either his experience with Exposition Press had soured him on the subsidy publishing game or he simply didn't have the money. Judging

There are more similarities between Burt Saunders, the "hero" of *The Flight Instructor Murders*, and writer Jack Drummond than he cared to admit. (PC)

by what happened next, the latter is quite likely. "A publisher told me crime fiction sales are slump," Drummond wrote. "He blames TV for saturating the genre. Claims real crime is in. Says Son-of-Sam sells."[17]

Fortunately, Drummond decided that "Son-of-Sam style [was]too easy, too safe but three banks is a challenge." So instead of becoming just another serial killer, he focused his energies on a plan to become a serial bank robber: "One man, one town, three banks, one day." Sort of a trifecta.

The fact that he was running low on cash may have also influenced his decision, but there is nothing in his background to suggest that he was a killer at heart. Writing about murders and committing them are two different things. Usually.

Drummond wrote that if he succeeded in carrying out his plan, the resulting book would be his third—and last. On the other hand, he felt that if he failed, he would die trying. He did not intend to let the police take him alive. Drummond clearly was a desperate man before he became a desperate criminal.

Divorced, the father of one child—a daughter—Drummond was unemployed with no apparent prospects. He seems to have put all of his eggs into one basket—becoming a successful writer. Now, that success hinged on whether he could rob three banks, get away with it and write a bestselling book (although his notes on this aspect of the plan are rather

vague). Clearly, any takings from even three bank robberies were not likely to sustain him for long.

Drummond had discussed his idea with a friend who told him it wasn't credible and that no "protagonist" would behave in such a manner unless he was crazy, suicidal or both. In short, it was a bad idea for a novel. His friend did not understand that the writer wasn't discussing some hypothetical plot. Drummond, of course, did not believe he was any crazier than the next man.

He did concede, though, that he might be suicidal. "The risk would be in the attempt on three banks not just one," Drummond wrote. "How close—how identical is the objective reality of crime to the writer's imagination of it? Murderers often sing but they don't write, and fiction writers don't kill."

At times, Drummond seemed to see himself as a social scientist who would be making a significant contribution to our understanding of the criminal mind. "The question if an actual crime would be more real. This would be the time to test this hypothesis. So my third and last book will be non-fiction. A how-to book for those who only stand and dream; a step by step instruction to oblivion."

Drummond mailed some notes and a manuscript off to his daughter, and afterward, she turned them over to the police:

> *BANK ROBBER*
> *Chapter One, Page One.*
> *I'm a bank robber.*
> *Beginning tomorrow.*
> *…That's chancy but what isn't?*
> *I'll work alone. Nothing original in that? ONE MAN, ONE TOWN, THREE BANKS, ONE DAY! Neat and tidy, and it shouldn't take that much additional time.*

A resident of the New York City Borough of Queens, Drummond felt it would be best to carry out his plan somewhere else—someplace where he wasn't known, but not a location that was so remote that no one would hear of the robberies. "The city should enjoy a brisk economy and be large enough to contribute to New York's store of out-of-town newspapers," he suggested. "Cleveland maybe or Columbus."

Drummond's final choice was based more on serendipity than solid research: "Columbus. Population—according to an old Rand McNally—is 485,000—say 650,000 by now. A town I haven't seen, named for the man who began it for us, and may finish it for me. Wish I could afford to wait

until Columbus Day, but that's too cute and I need the green now—another reason to begin research."

Having selected Columbus, Drummond rented an airplane from a flying club he belonged to in Farmingdale, New York, and flew it from LaGuardia to Port Columbus. He stashed a suitcase in a locker at the downtown Greyhound Bus Station. After the robberies, he planned to steal a car, drop it off at the bus station, pick up his suitcase and make his escape.

The night of Wednesday, June 14, 1978, Drummond wrote the following lines in his manuscript before sending it off to his daughter in New York: "Now for the hard part, I must close my eyes and sleep. Tomorrow will be an iffy day and the adrenalin runs. Will I be alive to sleep tomorrow night? Or will I sleep The Big Sleep?"

At about 10:15 a.m. the next day, the Columbus police radio room fielded several phone calls about a man who was changing clothes and had donned a wig between parked cars in a lot near 3636 Indianola Avenue. Three police cruisers were dispatched to the Clintonville address in a mixed commercial and residential area.

By the time Officer James Waggoner spotted the suspect, he was walking north through the Frisch's Big Boy Restaurant at 3785 Indianola Avenue toward the nearby Burger Chef Restaurant at 3825. Drummond was dressed in jeans, a light jacket, a plaid shirt and sneakers and was carrying a shopping bag.

Coming to a halt not far away, Officer Waggoner asked him to approach the cruiser. As he was doing so, officers Stephen Judy, Russell Jordan, Donald Blake and John Teele also pulled up.

When asked for identification, Drummond handed them a New York City library card and a handwritten ID of the sort that comes with a wallet. It bore the name George Redder, as well as an address, age and Social Security number. He also handed the officers some magazine clippings of articles he had written as Redder. As they were questioning him, David Verne, a robbery detective, also arrived on the scene.

Verne was curious about the shopping bag Drummond had placed on the ground between his legs and asked him what was in it. Drummond replied, "Nothing." Verne then asked if he could see for himself just for his own protection, and the writer said, "No."

The detective noticed the suspect had paraffin plugs in his ears of the type used when firing guns. As Verne bent over to take a look into the shopping bag, Drummond pulled a .32-caliber pistol from his waistband or pocket. Verne immediately raised his right arm to block the gun, causing Drummond to fire a shot into the air.

Mama's in the Furnace, the Thing and More

As they struggled, Drummond struck Verne with the butt of his pistol, and Verne shoved him back, spinning him around. Officers Judy, Jordan and Waggoner drew their revolvers as soon as the suspect's gun discharged and started shooting at him. He was three feet away from Waggoner and some ten feet away from the other two officers.

In the brief volley, one officer fired six shots, one two shots and the other one shot. Drummond collapsed on the sidewalk beside the Burger Chef and died. An autopsy later revealed that all nine shots hit him; one struck him in the head, two in his arms and the other six in the chest. Drummond's bullet had shattered the window at Frisch's restaurant but fell harmlessly between the glass and the curtains. A woman sitting several tables away bumped her head on the table while ducking for cover.

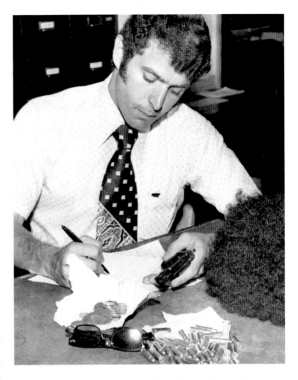

For his own safety and that of his fellow officers, Detective David Verne needed to see what Jack Drummond was concealing in a grocery bag. (CCJ)

When they opened the shopping bag, the officers found it held a loaded .45-caliber pistol, a fully loaded clip, several pages torn from a Columbus telephone book listing restaurants and banks, a map of Columbus and Franklin County, a blond wig, a black wig, several small brown bags with the words "Put the money in here…small bills…no change" and two loaves of bread.

It took about a month to identify Drummond. Initially, he was believed to be in his forties. He was five feet, nine inches tall, weighed 163 pounds and had brown eyes and gray hair. He was thought to be a resident of Long Island, New York.

A locker key found in Drummond's possession was traced to the Greyhound Bus Station, but the contents consisted only of some clothing. Consequently,

his body was held at the Franklin County Morgue while his fingerprints were sent to the FBI in Washington, D.C.

On Friday evening, a man arrived from New York thinking he could identify the body but was unable to do so. Drummond's fingerprints were not on file, suggesting he did not have a prior criminal record. Dental impressions were also taken in an effort to identify him.

A month later, the police obtained a positive ID by tracing the rented plane back to its owner. The man was Jack Drummond, fifty-five, from Astoria, New York. None of Drummond's friends or relatives was interested in making the trip to Columbus to identify the body, but they did send a photograph. Neither were they interested in claiming the body.

A form was mailed to Drummond's estranged wife asking permission to cremate his body. She was also asked to sign over $225 in Social Security death benefits to the funeral home to cover the costs.

The following biographical sketch was printed on the dust jacket of his novel: "George Redder joined the Air Force while living in San Francisco in 1943 and has been associated with aviation ever since. As a bona fide flight instructor with single-engine, multi-engine, instrument, and commercial certification, it is understandable that his first novel would be about a flyer. But, he assures us, the similarity ends there."

But did it? Burt Saunders, the protagonist of *The Flight Instructor Murders*, had this to say about himself: "I was thinking about becoming a criminal. I'm not one of those who consider all killing to be immoral so the idea didn't frighten me, but it didn't make me feel like fox-trotting either."

A few pages later, he says, "I'm tired of my life and the way it's not going. Damn few charters and fewer students, and little to live on or for. I owe three dozen bills, my plane is about to be repossessed, my prospects are zilch."

And, finally, after deciding to go ahead with his plan: "And I would shoot it out and get them or they'd get me. There and then I made compact with myself. The state would never use me as *Exhibit A*. To ensure that I must be prepared to die at any moment of any day. They could not take me. I would live free and die free, like a dog unconcernedly crossing the road until the moment he gets hit."

And that's pretty much what happened. Jack Drummond had written his own final chapter.

CHAPTER 13

THINK OF LAURA

"You will be alive," Judge George C. Smith told the defendant, Norman Whiteside, as he sentenced him to prison. "All that remains of Laura Carter will be the memories of her family and friends and a song."

The song, "Think of Laura," was inspired by the tragic death of the young Denison University coed and had spent eleven weeks in the Top 40. Although Whiteside had not been present at the scene of the crime, he was handed down the maximum sentence for conspiring to commit murder.

Coincidentally, Whiteside once had hit songwriting dreams of his own. A decade earlier, local deejay Bill Moss had hired the eighteen-year-old, self-taught musician to write songs for his Capsoul record label. But even then, people noticed there was another side to the perpetually smiling young man. As Dean Francis, who also was part of the Capsoul creative team, saw it, "That was part of his way of manipulating people. He got a plan for your ass. It's just that you don't know what it is until it's been done to you."

By all accounts, Gordon and Paul Ricardo Newlin grew up in a comfortable middle-class household on Columbus's near east side. The Newlin children—Gordon, Paul, older brothers David Jr. and Cecil and three sisters—attended East and Eastmoor High Schools. Their mother, Jeanne, worked in finance at Rickenbacker Air Force Base. Their father, David Sr., was a city employee who routinely decorated the family car to support the boys' basketball teams at away games. He was also a former member of the popular vocal group the Harmonaires, who had appeared in nightclubs and on radio for more than thirty years.

From the outside, the Newlins seemed like a normal, if not perfect, American family. From the inside, however, the picture was not as rosy.

In 1970, David Jr., the eldest son, killed two men during a drug deal gone wrong. Although the killings were ruled self-defense, the real trouble for the Newlins was just beginning. Three years later, the parents divorced. While their mother struggled to provide them with stability, heroin-addicted David Jr. became the de facto man of the house. Emulating their older brother, Gordon and Paul soon became involved in what family friend Ben Lay referred to as "the old style, gangster lifestyle."

Initially, the gangster lifestyle paid off big for the two younger Newlin boys, especially Gordon. At age twenty-one, he opened a nightclub on a site that has since been incorporated into Columbus State Community College. Naming the bar after himself, he set out to make Gordy's the most popular club in Columbus. He also treated himself to a Rolls-Royce, a house in the Bahamas and a lion named Hercules.

Then, in 1977, Gordon and his ex-wife, Dixie Lee Wasserstrom, were convicted of stealing precious gems from a mail truck. They were also found to be in possession of $200,000 worth of cocaine, heroin and opium. Gordon was sentenced to two years in federal prison and lost Gordy's.

Upon his release, Gordon quickly fell back into his old ways. He joined forces with James Wesley "Bubbles" Smith and Norman Whiteside. In addition to supplementing his income by "victimizing others" (as music critic John Petric described it), Whiteside had fronted a band called WEE and recorded one album, *You Can Fly My Aeroplane*, for the local Owl label.

According to court records, Gordon Newlin, Smith and Whiteside (abetted by a Los Angeles drug dealer, Charles "DeeDee" Straughter) would come to be known as the "Home Team." They were fairly successful in their criminal enterprises until 1982, when Larry Doby Canady, Melvin Thomas and Sylvester Littlejohn came down from Cleveland in an attempt to muscle their way into the Columbus drug market. These three interlopers, dubbed the "Visiting Team," wanted a 35 percent cut of the action.

Born into a family of eight children, Canady was raised by a single mother, Elizabeth Mitchell-Dulaney, who, like Jeanne Newlin, tried to keep her family together while working a full-time job. His brother, Robert, served time for robbery; another brother, Jerome, was killed at the age of nineteen in a "boarding house dispute." A niece and nephew, children of his sister Bobbie, were both murdered within the same month.

The opening volley of an all-out war between the Home Team and the Visiting Team occurred at 4:30 a.m. on April 16, 1982, when Melvin Thomas shot James Smith outside a "boot joint" (i.e., after-hours club) on the east

side. Immediately, the Newlin brothers and Whiteside began plotting their revenge on Thomas and his partner, Larry Canady.

Now, most people don't get too concerned about gang warfare as long as "they only kill each other."[18] Unfortunately, the second act of this tragedy happened to coincide with Parents' Week at Denison University. Professor and Mrs. Edward Carter had flown in from Philadelphia to visit their daughter, Laura, eighteen, a freshman. The afternoon of April 17 they watched her compete against Oberlin in a women's lacrosse game and then afterward made the thirty-five-mile trip to Columbus in a rental car to celebrate the 11-1 victory.

At about 8:10 that evening, the Carters were driving their daughter and three of her friends to a downtown restaurant for dinner. Laura was sitting in the back seat with two of her schoolmates as they drove west along East Broad Street near East High School, approaching Winner Avenue.

A few moments earlier, another car with Gordon Newlin behind the wheel had turned onto Winner Avenue. As Canady testified, he had just dropped his two companions off at their car with the intent of following them across East Broad Street when he heard several shots.

"I didn't know at first where it came from," he said. As he started to speed away, he saw "Gordy Newlin's car" pulling out of a gasoline station parking lot and heading north on Winner. He thought he would follow it, but Newlin made a U-turn and came straight toward him. He said that someone shot at him from the vehicle, and he fired back.

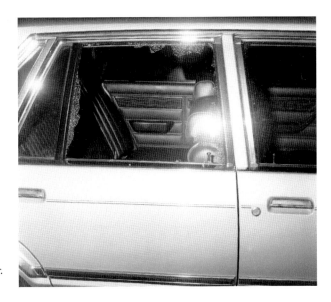

Professor Edward Carter's first thought was that someone had thrown a rock through the rear passenger-side window of his rental car. (CPD)

More than a block away from the action, the rear passenger window of Carter's car exploded, and a single .38-caliber slug tore into Laura's chest, damaging three major blood vessels before lodging in her left lung. "I thought someone had thrown a rock at the car," Professor Carter said. But when he asked if everyone was all right, Laura didn't respond. Within the hour, she died at nearby St. Anthony Hospital, where she was carried in by her father. She was his only child. "We had two happy days together," he said. "She was a terrific girl, cheerful, optimistic."

Christopher Cross, a Grammy award–winning recording artist for his 1979 debut album, happened to be dating a friend of Laura's. Moved by his girlfriend's grief, he wrote the song "Think of Laura," which was released as a single from his *Another Page* album. The single peaked at number nine on the Billboard Hot 100 chart in 1984. The song then took on a life of its own when it was used by producers of the soap opera *General Hospital* to advertise a plotline centered on two of its major characters, Luke and Laura, played by Anthony Geary and Genie Francis.

Although the public was horrified by Laura's death, the war was not over.

On October 19, 1982, Paul Ricardo, Gordon and David Jr. kidnapped Sylvester Littlejohn in Columbus. They drove him north to Delaware County, shot him and left him for dead in a field off Smothers Road. He was rescued by a passerby after he managed to crawl to the highway. Gordon was acquitted of the offense, but David Jr. was convicted and sentenced to fourteen to fifty years in the Chillicothe Correctional Institute. Meanwhile, Paul had fled the state, reportedly to the U.S. Virgin Islands and then to Miami.

Despite all the public attention paid to Laura's death, it would be three years before police finally unraveled exactly what happened and who was responsible. Columbus police captain Antone Lanata told the *Columbus Dispatch*, "We went down a lot of false paths, and we had to recoup our losses and regroup. This case is very convoluted and confusing."

In August 1985, Gordon Newlin, Paul Ricardo Newlin, Norman Whiteside and intended victim Larry Canady were indicted for their respective roles in her death. At the time, Canady was serving a three- to ten-year prison term for 1983 weapons convictions. Whiteside was already doing twelve. Although Thomas was not indicted in this case, he was sentenced to four to twenty-five years on an unrelated robbery charge.

After hearing the news of his indictment for the murder, Gordon Newlin turned himself in to police, although he stated through his lawyer, Elliott Van Dyne, that he was surprised to be accused. "You never expect to be charged with something you didn't do."

Mama's in the Furnace, the Thing and More

Van Dyne described his client as "a businessman" but refused to discuss the nature of his business. While he did not deny that Gordon was there the night Laura died, he insisted he was not involved in her death. "His car was all shot up. People opened fire on him there. There may have been a gang war going on then, but Gordon wasn't in it."

The first of the four to be convicted, Canady was sentenced to only six months in prison on two counts of aggravated assault. Judge Patrick West gave the minimum sentence to Canady in an effort to persuade him to cooperate with the authorities and assist in convicting Norman Whiteside and the Newlin brothers.

A freshman at Denison University in Granville, Laura Carter was enjoying an evening out with her parents and friends. (CD)

Laura's father told the press he was upset with the sentence. "I don't think you can go around shooting people who come to your city as guests and get off scot free." The maximum sentence for aggravated assault, however, would only have been eighteen months.

Whiteside was convicted in 1986 of two counts of conspiring to commit murder and sentenced to fourteen to fifty years, in addition to the twelve-year sentence he was already serving for forgery. Although he was not with the Newlins the night Laura Carter died, he did have knowledge of the incident and later turned the murder weapon over to the police. He also admitted he had planned to kill Melvin Thomas but changed his mind after the earlier shooting in which James Smith was shot in the leg. He maintained that Smith was the only one who continued to talk about killing Thomas. "Bubbles said, 'As soon as I see Melvin, I'm going to kill him.'"

Although he charged that the proceedings were political, Whiteside took his sentence well, telling Judge George C. Smith, "You do what you have to do, and I will abide by it." He also felt he had been double-crossed because he had cooperated with police in solving the crime. Gordon Newlin was convicted

Popular singer/songwriter Christopher Cross wrote and recorded "Think of Laura," which peaked at No. 9 on the *Billboard* singles chart in 1984. (PC)

a year later of aggravated murder, conspiracy to commit aggravated murder, involuntary manslaughter and felonious assault.

Paul Ricardo Newlin managed to stay off police radar for over ten years. Columbus police detective Robert Young likened him to a ghost, saying, "A lot of people led us to believe he was dead and with Jimmy Hoffa. I didn't think he was dead." In 1992, Paul was arrested by FBI agents while attending an Alcoholics Anonymous meeting in Colorado. He had been living in the state for many years using the aliases Richard or Ricardo V. Anderson while working as a carpet installer.

During his trial, Paul maintained he did not kill Laura. He claimed he was only armed with a short-barreled derringer. Had he anticipated there was going to be a battle with the Visiting Team, he asserted he would have been packing something a little larger. However, Paul did express remorse for not coming forward with his side of the story earlier, acknowledging, "I'm guilty of obstructing justice. If I had told the truth then, we wouldn't be here."

Paul maintained that, while living in Colorado, he had found God. During breaks in the trial, he read from the Bible, which he kept in front of him. After sentencing, he "forgave" the prosecutors and said that he prayed for Laura Carter's family.

The Newlins' old rival, Larry Canady, testified at Paul's trial but refused to take the witness oath. He used derogatory terms to refer to the attorneys and shouted out, "Ricky, you got an all-white jury, man…and you're on trial for killing a white girl."

Paul was sentenced to nineteen to sixty-five years in prison on the legal principle of "transfer of intent." Since he intended to kill another person,

the law said he was also guilty of unintentionally killing Laura Carter. In addition, he was indicted for the kidnapping and attempted murder of Sylvester Littlejohn, but that case ended in a mistrial.

Coincidentally, the assistant prosecutor in the case, Cynthia Taylor, had been a friend of Laura's in college. She said of Paul Ricardo Newlin, "I do believe the defendant is a menace to society, and he should be locked up for a long time."

The Newlin brothers and Whiteside contend that it was James "Bubbles" Smith who accidentally killed Laura Carter while attempting to shoot Melvin Thomas, although Smith was never brought to trial. The police confirmed that the bullet came from a gun that was in his possession.

Despite his narrow escape from death and a plea bargain agreement that sent him to prison for only six months, Larry Canady could not avoid the law forever. In 1989, he was convicted of killing his ex-girlfriend, Eve Dennis, and injuring her new boyfriend, Paul Farmer. During sentencing, Canady caused a loud disturbance, refused to take the witness stand and attempted to walk out of the courtroom before Judge David Fais had finished talking.

While Canady claimed to be remorseful, the judge did not believe him. He was sentenced to life with no chance of parole for thirty years for Dennis's murder and consecutive terms of seven to twenty-five years for the attempted murder of Farmer, plus an additional three years for using a gun to commit a crime. The earliest he will be eligible for parole is 2027, at which time he will be seventy-four years old.

On Labor Day 1999, Larry Canady's mother, Elizabeth Mitchell-Dulaney, shot a suspected drug dealer outside the South Fourth Street home she shared with her five great-grandchildren—Ivory, Rodney, Isaac, Khalfani and Isawan—all of whom had been orphaned or abandoned as a result of violent crime and drug abuse.

While her neighbors felt she had performed a public service, "Granny" was sentenced to prison for three and a half years for felonious assault with a gun. Governor Bob Taft commuted her sentence in 2002, but she died in January 2004, a few weeks before her pardon hearing was scheduled to take place. With no other suitable guardian in the family, the children were placed in foster care.

Although Norman Whiteside remains in prison, a new generation is discovering his 1977 album, which was released on the Chicago-based Numero label in 2008. However, there is little chance he will be touring in support of it anytime soon.

Meanwhile, Laura Carter is only one of a growing number of innocent bystanders who have been struck down by gang violence in Columbus. So, think of Laura, but also think of Tiana…and Nyomi…and Jason and Willie and Davon and Gary and Phillip and Aasaun and Gary and Alix and…

CHAPTER 14

THE BUDDY SYSTEM

On Friday, April 11, 1986, the other shoe finally dropped.

Detective David Morris, of the Columbus Police Department, was working second shift alone when a call came into the Homicide Unit. It was from the Delaware County Sheriff's Office. "Do you know a William Matix?" he was asked. "Yeah, why?" Morris replied. "We've been getting inquiries from the FBI," the caller said. "Matix and another guy, Michael Platt, have been killed in a gun battle in Miami. Two of their agents are dead."

Morris immediately flashed back to a Friday afternoon three years earlier. It was December 30, 1983. He had fielded that phone call, too. At 5:15 p.m., the police radio dispatcher notified him that "the body of a woman had been found lying face down in a pool of blood" at Riverside Methodist Hospital. Actually, there were two victims, and one was the wife of a William Matix.

Now retired, Morris asserts that the Riverside murders was "the goddamnedest investigation" he was ever involved in. Nearly thirty years later, it still haunts him. To this day, when he runs into any of the dozen or so officers who participated in the investigation, they take a few minutes to catch up before spending the rest of the time talking about the unsolved deaths of two lab assistants, Joyce McFadden and Patricia Matix. After all, the six or seven of them who had been the "nucleus" of the investigation had lived it seven days a week, twelve to fourteen hours a day.[19]

Although Bill Matix had never been an official suspect in the slayings, he wasn't above suspicion, either. And he wasn't exactly cooperative. For example, he refused to take a lie detector test, purportedly on the advice of a highway patrolman who later said he had, in fact, told him just the opposite.

Mama's in the Furnace, the Thing and More

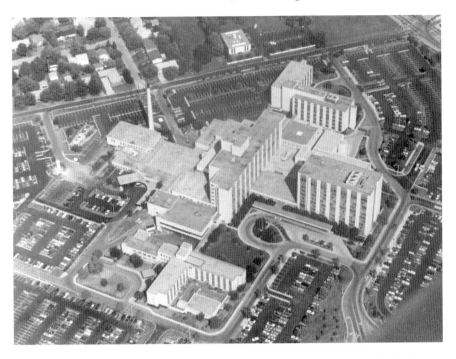

Originally incorporated as Protestant Hospital in 1891, Riverside Methodist Hospital moved north to its present location seventy years later. (CCJ)

Soon after Morris took the call from Delaware, he and his partner, Michael Elkins, packed their bags and were on their way to Florida to see if this new development could shed any light on their still open case.

In October 1985, a rash of robberies began in Dade County Florida. The thieves used stolen vehicles to rob banks and armored cars. During one incident, a security guard for Brink's was shot in the back by a gunman, and then, while he lay on the ground bleeding, a second gunman shot him again. The guard survived the incident and was able to provide the police with descriptions of his assailants.

Also assisting the police was Jose Collazo. On March 12, 1986, while shooting at tin cans in a remote quarry in the Everglades, Collazo was kidnapped, shot four times (once in the head) and left for dead in a shallow canal. After his assailants stole his car, a black Chevrolet Monte Carlo, and two guns, Collazo crawled one and a half miles for help. He was at least the second victim to have his car stolen.

Earlier, a twenty-five-year-old man went missing in the same quarry, but he did not fare as well. The pair stole his white pickup truck and were driving it

when they robbed the Brink's truck. The owner was never seen alive again, although a skeleton found in the area is believed to be his. On March 29, the *Miami Herald* reported that at least three men had been shot in the same rock pit.

In an all-out effort to catch the perpetrators, FBI agent Gordon McNeill authorized a "rolling stakeout" on April 11, 1986, involving eight agents, including Gerald Dove, Benjamin Grogan and John Hanlon. Using three unmarked cars, the agents drove around Suniland Shopping Center, south of Miami, looking for the Monte Carlo, which had been used in the robbery of the nearby Barnett Bank.

At 9:20 a.m. on what was later dubbed "The Bloodiest Day in FBI History," agents Grogan, fifty-three, and Dove, thirty, spotted the "hot" car and called for backup. They were joined by the two other unmarked cars. William R. Matix, thirty-four, was behind the wheel, and Michael Lee Platt, thirty-two, was, literally, riding shotgun. It is believed they were planning to commit another robbery in the vicinity, since a getaway car was stashed nearby. However, when Matix realized they were being followed, he took evasive action.

The agents responded by "boxing" the Monte Carlo in with their own cars, causing it to crash into two parked vehicles. In the ensuing firefight, Grogan and Dove were both fatally wounded by a Ruger Mini-14 rifle, becoming only the twenty-eighth and twenty-ninth agents killed in the line of duty in the seventy-eight-year history of the Bureau.

"I got shot in the hand," said agent John Hanlon, forty-eight, in an interview with *People* magazine.

> *My hand exploded, and I flopped over on my back and looked to my left and saw the guy standing by the car. Then he came around and shot me again on the ground in the groin. There was a lot of machine-gun fire, and all the casings came down on me.*
>
> *I heard Ben go, "Oh, my God," but I didn't feel him fall down. Then Jerry Dove fell right next to me, his head face down. Jerry raised his head, his eyes were closed, and the guy who I think shot me, shot Jerry in the back of the head. Executed him. I could see the bullet hole in the back of his head. I was lying on the ground, and I, honest to God, I thought of my wife, my three kids. I wasn't thinking, "I gotta see Paris," but I wasn't ready to die. I thought, "I hope he doesn't put the gun against me." I know I felt he was going to kill me.*

The desperados also wounded five other agents: Richard Manauzzi, Gilbert Orrantia, Edmundo Mireles, Gordon McNeill and Hanlon. Despite a shattered arm, Mireles was able to struggle to his feet and "stonewalk" to the side of the immobilized Monte Carlo, where he fired another six rounds into the two men

Mama's in the Furnace, the Thing and More

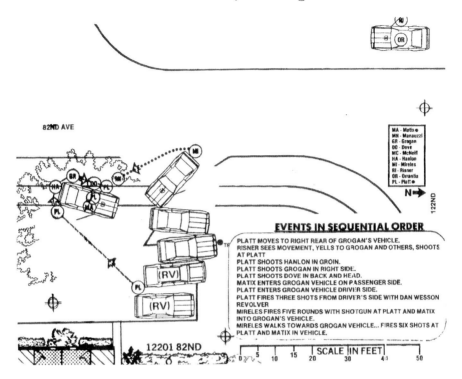

Next to the assassination of President John F. Kennedy, the FBI firefight in Miami is said to be the most thoroughly analyzed shooting in history. (PC)

with his Smith & Wesson revolver. William Matix and Michael Platt were finally dead. According to FBI director William Webster, "They were two particularly violent individuals who did not shoot out of excitement or fear."

In the aftermath of the Miami shootout, Dr. Emit Ray, pastor of Riverside Baptist Church in suburban Kendall, Florida, where Matix was a member, was asked his opinion of the man. "He was distraught over the death of his wife, but it did not reveal any deeper psychological problems. Was he really a phony? I don't know that I will ever know. I do believe the church must retain its vulnerability. If we become too careful and questioning, we may lose our compassion."

The Miami incident is often said to be the most analyzed shootout in history. In roughly five and a half minutes, the officers had fired seventy-five rounds of ammunition, while Matix and Platt had fired sixty-five. Unbelievably, Matix had been hit six times and Platt twelve, including paralyzing shots to the spine. Yet both men continued their deadly barrage. But that was all secondary to what Detectives Morris and Elkins were there to find out. They wanted to know if Bill Matix had also killed his wife and her co-worker.

It was late afternoon on December 30, 1983. Patricia "Patty" Matix, age thirty and a new mom, and colleague Joyce McFadden, thirty-three, were working in the cancer research laboratory of the hospital. They were alone because their supervisor, Dr. Devi Munjal, was on vacation. About 5:00 p.m., Munjal stopped in just to pick up his mail. He found Joyce's body first. She had been hogtied and gagged with tape, her throat had been cut and she had been stabbed nineteen times. Her wedding rings were missing.

Dr. Munjal called hospital president Erie Chapman, who immediately summoned the hospital's legal counsel, Frank Pandora. Meanwhile, Dr. Munjal sought out his associate, Dr. Edward Bope. Making his way to the scene, Dr. Bope examined Joyce's body and found she was still warm. Only after hospital security and administration had arrived (and "trooped around the crime scene," Morris recalls) was the decision made to notify the police.

The first officer on the scene was a plainclothes SWAT team member. She began a search of the laboratory and made a second gruesome discovery. The body of Patricia Matix had been left in a four- by six-foot "cold room" used for preserving specimens. A towel had been placed under the door to prevent blood from flowing out into the office area. Like McFadden, she was bound, gagged, her throat was cut and her wedding rings were taken. She had been stabbed sixteen times. The heads of both women were almost severed from their bodies. McFadden's desk had been rifled and her purse emptied. Several boot prints in the women's blood and some 150 fingerprints (one of which was matched to William Matix) were found by the police.

Police were able to match the bloody "BIG MAC" boot prints to a specific type sold exclusively at J.C. Penney stores. After searching through forty thousand credit card receipts, Morris and the other detectives working the case discovered that the same type of boot had been purchased by a construction worker who just so happened to be working at Riverside. And he did not have a credible alibi for the time the police believed the women were killed.

However, after searching the man's home, they were unable to find any evidence connecting him to the crime. Furthermore, the soles of his work boots were far too worn down to have produced the print found at the scene. Morris also pointed out that the man had been cooperating fully with the investigation up until the local media reported he was a suspect.

The Columbus police used every tool available to them in an effort to solve the murders. When it was discovered that at 4:30 p.m. on the day of her death Joyce McFadden was paged to call the laboratory phone number, the switchboard operator was questioned extensively regarding the unknown caller and even hypnotized in an effort to help her remember. Hundreds

of leads were painstakingly followed, and "psychic investigators" were also consulted, but to no avail.[20]

Although the family of Joyce McFadden was readily accessible, all residing locally, very little contact was made at the time with the family of Patty Matix, most of whom lived in the coal region of Pennsylvania. Also, there were so many other leads to follow up on that a trip to Pennsylvania was vetoed because it was felt it would not justify the cost. Morris believes that had they been permitted to make the trip, Matix would have been their prime suspect from the beginning. It was not until three years after the murders that Patty's family finally met with Columbus police and informed them just how much they had despised Patty's husband for the way he treated her.

After his wife's murder, William Matix left Ohio with his infant daughter and more than $375,000 in life insurance and worker's compensation payouts. At the time of his death, he was still attempting to gain an additional $3 million from a wrongful death suit against the hospital he filed two years to the day after his wife's murder. In the suit, he alleged that Riverside did not provide enough security to prevent his wife's death.

According to Doris M. Miller, who wrote a story on him for the March 1986 issue of *Home Life Magazine*, Bill Matix joined the marines in 1970. After a three-year stint, he enlisted in the army. Originally a paratrooper, he was relocated to Walter Reed Hospital due to a stuttering problem. While in Washington, D.C., he met Patricia Buchanich. She was also in the army and worked as a technician in the cancer research laboratory. The two married in 1976 and then moved to Ohio, where they became born-again Christians. Their daughter, Melissa, was born on October 4, 1983.

Matix claimed in the article to have been at his home in rural Delaware County with his infant daughter when he learned of his wife's murder. This alibi was impossible to corroborate. He told the reporter for the Christian-oriented publication, "At home I was beating the walls in desperation. Finally, I knew I had to submit to God's presence. God didn't kill my wife. He allows things to happen for a reason."

While stationed at Fort Campbell, Kentucky, Matix met fellow soldier Michael Platt of Bloomington, Indiana. Morris is not surprised the two men bonded so quickly; Matix, he says, was "a spell-binder." There were suggestions that the two of them had actually begun committing weekend "stick-ups" in small towns while still in the service.

Buddy, as Platt was called by his friends, moved to Florida shortly before Matix and then urged his friend to join him. Soon, his wife also died under violent and suspicious circumstances. On December 21, 1984, less than a year after Patty

Matix was murdered and six months after Bill Matix moved to Florida, Regina Platt, mother of three, was found dead. She allegedly shot herself in the mouth with a shotgun while her husband, Michael, was in the next room.

Regina Platt's death was ruled a suicide, although Morris claims that when he and his partner tracked down the investigating officer, he disagreed with the finding. He said that when he told his sergeant he thought it was a murder, he was told, "We've got plenty of homicides—this looks like a suicide, so it's a suicide." The officer was then transferred to airport duty.

Regina's sister hinted at the existence of a letter that indicated that Matix and Platt were not only involved in Regina's death but also in Patty's and Joyce McFadden's murders. She also suggested that Platt may have coerced his wife into a sexual relationship with Matix (Platt later claimed that the "affair" with Matix was the reason for his wife's suicide). Platt was Regina's second husband. She left her first, also a military man, after beginning her relationship with Platt. At the time of her death, Platt was believed to have been involved with at least two other women.

Detective Morris acknowledges that they entertained the possibility that Matix and Platt may have made a pact a la the Alfred Hitchcock film *Strangers on a Train*, in which one man suggests to another that they commit reciprocal murders. A former baby-sitter told Columbus police that Matix once expressed a desire to kill his own stepmother, and when she had said he would never get away with it, Matix responded, "You can hire someone to do things like that."

In Miami, Matix and Platt founded Yankee Clipper, a general lawn-care service. Matix boasted to friends and relatives that he and Platt were working as freelance CIA agents who robbed Miami area drug dealers. As evidence of his Robin Hood lifestyle, he showed them a large arsenal of guns. After his death, Tim Platt said, "My brother didn't own any guns, to my knowledge. He was a smiling, happy guy, no drinking, no drugs, no smoking. He was not your typical criminal." According to Morris, the FBI was extremely concerned that Matix might have been tied to the CIA in some fashion, but the only "CIA" document they turned up was his diploma from the Culinary Institute of America.

Both Platt and Matix remarried after moving to Florida—Platt to a woman he had begun seeing before the death of Regina and Matix to a woman named Christy, whom he met at Riverside Baptist Church. Their pastor, Dr. Ray, said Matix joined the church because "he was lonely and distraught, and he was much concerned about his little girl. He was active in our group of single people, and he dated several of our girls. He even asked three of them to marry him. One of them said to me yesterday, 'I almost did marry that guy!'"

Mama's in the Furnace, the Thing and More

Christy, already pregnant, married Matix in May 1985. They divorced just two months later, and she gave birth to their son in December. At the time, Christy believed that Matix was distraught over the failure of the Yankee Clipper company. She knew nothing of the $375,000 from Patty's life insurance or the estimated $100,000 he and Platt made from the robberies.

With Matix safely dead, a marriage counselor, a minister and an Ohio State Highway patrolman and his wife came forward to give testimony that they had not felt at liberty to give while he was still alive. Taken together, it portrayed him as exactly the type of violent and manipulative individual who might have been capable of killing his wife.

Morris and his fellow detectives made several trips to Florida. They would stay down there until they "ran out of clothes, money, everything." Although they would get tired and want to leave, once they were home in Columbus, they couldn't wait to go back. Working with the FBI, "to the extent you can ever work with them," they became convinced that Matix had done it—had killed his wife and Joyce McFadden.

This is what Detective Morris thinks happened. William Matix went to the cancer research lab with the intent of killing his wife. He brought a knife with him for that purpose. He knew the schedule well. When he arrived, Patty was working alone because Joyce had gone to the library to do some reference work. He killed his wife and hid her body in the adjoining cold room, placing a towel under the door to keep the telltale blood from seeping out. He then phoned the telephone operator to have her page Joyce to return to the lab "stat"—immediately. ("Stat" is a bit of medical jargon that would not normally be applied to a situation in a research lab, something Matix may not have known.)

Matix waited in the office for Joyce to return and then killed her, too. Her death would be a "red herring." He dumped their purses and stole their rings to make it look like they had been the victims of a robbery gone wrong. It was a good plan, well executed. Although it was the bloodiest crime scene Morris had ever witnessed, there was only one clear footprint. "It was a masterful plan," Morris concedes.

Morris would still like to see the case against Matix pursued in order to bring closure to the Riverside murders but knows it is unlikely to happen at this late date. And so he continues to revisit it in his mind.

An article in the *Columbus Dispatch* noted that on August 30, 1984, Morris woke up and walked into the kitchen, where his wife greeted him with a hug. "Do you know what today is?" she asked. Morris immediately replied, "It's the eight-month anniversary of the Riverside slayings."

"Thanks a lot," his wife said. "It's our wedding anniversary."[21]

CHAPTER 15

THE NINJA DRAG QUEEN KILLER

By all accounts, Brazon McMurtry was a friendly girl. According to her friend Cher Andrea, people wanted to be around her. She was a beauty queen who was twice ranked nationally and won the Ohio crown in 1994. Her favorite singer was Dolly Parton, and she filled her home with photos of Dolly and other memorabilia. She was also an activist who held an annual benefit to support the Columbus AIDS task force. But first and foremost she was an entertainer who had performed in thirty-six states and regularly did shows six nights a week.

Brazon McMurtry was many things, but one thing Brazon McMurtry was not was a woman.

Gary McMurtry grew up in rural Utica, Ohio, north of Newark and some forty miles from Columbus. It is unclear exactly when McMurtry first met Michael Jennings. T.A. Kevlin, author of *Headless Man in a Topless Bar*, claims the pair had known each other for more than ten years and during that time had been lovers.

Jennings was a male stripper who used the stage name Devon when he performed. He was described by friends as sweet and quiet. In a May 2002 article in the *Columbus Dispatch*, co-worker Stefan Heston said, "[Jennings] wouldn't even eat meat because of the killing of animals."

McMurtry worked several nights a week at the Columbus Eagle, a gay strip club owned by Eric Jundt, where students of The Ohio State University got in free on the weekends with a valid BuckID. McMurtry hired Jennings as one of several acts to appear as warm-ups to his drag show. While McMurtry sang songs and told jokes in the persona of Brazon, Jennings, as Devon, often donned a black ninja costume, which he then stripped off for the enjoyment of the primarily gay, male audiences.

Mama's in the Furnace, the Thing and More

Michael Jennings always wore a ninja outfit when he was performing as "Devon," the name he used as a stripper in gay nightclubs. (CPD)

Jennings was known to appreciate Japanese warrior culture and often carried a Japanese sword on his back. When asked, he would tell people it was a pool cue, but friends said he considered the sword his most valuable possession and always kept it with him for fear that it would be stolen.

Perhaps McMurtry should have been more guarded with his life, but his openness was one of the things that his friends loved about him. In late April, his home at 3485 Indianola Avenue, formerly the residence of a local television personality turned professional woodcarver, had been burglarized. The thief was never caught. Still, as Brazon, McMurtry poked fun at the incident and incorporated it into his stage show.

It was early May 17, 2002, and all the residents of the modest home, just across the street from Olympic Swim & Racquet Club, were asleep. Sharing the house with McMurtry were his friend, make-up artist and hairdresser Brian Bass, and two other roommates, Brian Balk and Scott Kohl, who, in

HISTORIC COLUMBUS CRIMES

Jennings was so accustomed to carrying a samurai sword with him wherever he went that his friends no longer gave it much thought. (CPD)

a move that would later prove very lucky for Kohl, were out of town at the time. McMurtry and Bass must not have been asleep very long, because Eric Jundt saw them leave the Columbus Eagle Club, where all four housemates worked, at 2:30 a.m.

About 7:00 a.m., Bass awoke to the sound of McMurtry fighting off an attacker. When he opened the door to his room, he discovered a masked man dressed as a ninja. Bass fought with the intruder in black, who pulled a thirty-inch-long katana, or samurai sword, from a sheath strapped to his back. Apparently, he had entered through a glass door at the back of the house.

Bass suffered only defensive injuries to his hands. McMurtry was not so lucky. He had been stabbed thirteen times, including a fatal wound to the heart. He was pronounced dead at nearby Riverside Methodist Hospital. The thirty-five-year-old was eulogized in both the June 25, 2002 issue of the *Advocate* and the December 2002 issue of *Out*, two national magazines dedicated to gay news and issues.

The *Out* obituary described Jennings as both McMurtry's murderer and former lover. Although it would be nice to think that McMurtry's death made national headlines because of his philanthropic work with the Gay Community People's Choice Awards, an annual benefit for the Columbus AIDS Task

Mama's in the Furnace, the Thing and More

Force, the truth is that the story of the drag queen and his ninja killer was so sensational that it even appeared in the French homosexual publication *Tetu(e)*.

The assailant fled the scene through the normally quiet north Columbus neighborhood of Clintonville, running between houses and through backyards, where he was spotted by several witnesses. Called to testify at the trial were Jeff Linden and Jeffrey Soiu, who were meeting a friend for an early tee time; neighborhood resident Martha West, who saw a man in black hide in some bushes as a van passed; and Josh Ruark, a worker with the electric company, who attempted to apprehend the armed man.

A 7:15 a.m. call from Bass to the Columbus police led to the arrest of two men in black found in the area. One, chased by police dogs to a residential front yard on High Street, just a block south of the Whetstone Library, was arrested at 8:00 a.m. carrying a bloody sword and a backpack containing masks, two swords, two knives, a crossbow, bags of flour, some tubes of pepper, shoes, nunchucks, throwing stars, a road flare and some pieces of glass, which probably fell into the backpack when the suspect broke the door of the house.[22]

When the masked suspect was identified as thirty-year-old Michael Jennings, it was discovered that the outfit he wore for the murder was the same costume he wore as a stripper.

Bond was set at $1 million, and due to the strangeness of the case, Jennings was committed to Twin Valley Behavioral Health Care. In December, he was found mentally incompetent to stand trial. He was also forcibly injected by court order with antipsychotic medication, based on his statement that he was "on a mission to spread world peace." It was hoped that after three months of treatment, Jennings would again be capable of standing trial. Instead of three months, it took two years before he was deemed competent. Against his wishes, his lawyers entered a plea of not guilty by reason of insanity.

Jennings also waived his right to a jury trial and chose instead to plead his case in front of a panel of three Franklin County judges. It was a strategic move by his defense to spare his life. Although Jennings's crime made him eligible for the death penalty, all three of the randomly selected judges would have had to unanimously agree to sentence him to death.

In August 2005, three years after the death of Gary McMurtry, Michael Jennings took the stand in his own defense, claiming that he broke into McMurtry's home and then attacked and killed the former Miss Gay Ohio in self-defense. He told the court that he had never admitted to the murder because he did not believe that he had committed a murder. What he did believe was that McMurtry and his roommate, Scott Kohl, had previously

killed two people and that they were planning on killing him next. In court, Jennings said, "How many people does someone have to kill before someone else takes action?" One of McMurtry and Kohl's so-called "victims" was performer Chris "Peg" Penn. According to medical reports, Penn died of a heart attack after a show at the Columbus Eagle Club.

The trial lasted only four days, two of which were given over to the testimony of psychologists who had evaluated Jennings over the past three years. While under observation, he claimed to be the archangel Michael. Like the Biblical angel, Jennings believed it was his job to send evildoers to hell. He also felt a kinship to Saint Joan of Arc, who believed she was receiving messages from the same angel Michael. A Catholic priest from the Pontifical College Josephinum in Worthington testified that in 2000, Jennings had come to him seeking sanctuary, brandishing the now infamous sword and seemingly acting out a scene from the movie *The Messenger*.[23]

The psychologists also testified that at times Jennings professed a belief that if he were to join the Columbus Crew, a major league soccer team, they would win the World Cup. After the World Cup victory, he would be interviewed by the media and he could then deliver his message of world peace on television. Owing to his testimony, the Crew filed a restraining order against Jennings.

Before the verdict, Jennings's father read a letter in which he apologized to Gary, his friends and loved ones for the murder and to his own son for not seeing the signs that he was losing his mind and responding sooner. He ended with the admonishment, "Pray that this doesn't happen to one of your children."

In his closing statement, the defense attorney chastised the court for, in his opinion, incorrectly pronouncing his client competent to stand trial after reversing the original judgment that he was not. He also attempted one last time to exploit the sexual orientation of the victim, and possibly the suspect, by stating, "There are people who think it's not moral and it's illegal to be gay. I am simply asking the court to keep an open mind."

Jennings was sentenced to twenty-five years to life for the murder and another five years for the burglary and assault of Brian Bass, for a total of thirty years to life. In July 2006, Jennings appealed the verdict, asserting that he had established through evidence that he was not guilty by reason of insanity and that the verdict of the three-judge-panel was incorrect and not supported by the evidence. The original verdict was upheld.

It is clear that Michael Jennings wanted Gary McMurtry dead. What is not so clear is the exact nature of the relationship between the two. According to

Michael Bishop, a former roommate of McMurtry who performs as "Beverly Ford," Jennings had been in the house before the night of the murder as a welcome guest who participated in long discussions in the kitchen. Court records state that Jennings considered all four residents of the house to be his friends and that he visited the house as often as twice a week.

Rumors persist in the large Columbus GLBTQ community, no doubt aided by the *Out* obituary and the claims of several authors, that Jennings and McMurtry were on-again/off-again lovers, although court records deny that Jennings was ever romantically linked to anyone in the house.

Originally, many believed the murder of such an outspoken member of the Columbus gay scene to be a hate crime. Jennings's own involvement in the community, as well as his testimony that the murder was in no way connected to sexual orientation, make this scenario unlikely.

According to the competition's website, Brazon is one of eighty-six former Miss Gay America titleholders, contestants, promoters and supporters who have died since the pageant was founded in 1972, including two other contestants from the 1994 pageant. The promise at the end of the page is that all the "girls" who "left this world much too soon" will be remembered.

In the usually quiet neighborhood of Clintonville, the murder of a popular drag queen by a gay ninja stripper will not be soon forgotten.

CHAPTER 16

THE DAY THE MUSIC DIED—AGAIN

Every year on December 8, girls with long, shaggy hair and guys with even longer, shaggier hair gather at a small club on Sinclair Road, between the railroad tracks and the freeway on Columbus's far north side. They stand together in the parking lot, drinking Coke and whiskey out of plastic cups (preferably, a shot of Crown Royal for that "black tooth grin")[24] and toasting the memory of the departed guitar god they called "Dimebag."

On the same day, more than five hundred miles away at the edge of Central Park in New York City, another group of equally shaggy devotees congregates in a memorial garden called Strawberry Fields, singing, lighting candles and strewing flowers in remembrance of their fallen idol.

The story of John Lennon is well known. He was born in 1940 in Liverpool, England. After a difficult childhood, he rose to prominence as a member of the Beatles, the most famous rock band in the world. His life ended tragically in 1980 when, after more than two decades of music and controversy, he was shot to death outside his apartment building by Mark David Chapman, an emotionally disturbed young man who suffered from delusion that he was part Holden Caulfield (the alienated hero of J.D. Salinger's novel *The Catcher in the Rye*) and part devil.[25]

Slightly less known is the story of Darrell Abbott.

Darrell Abbott was born in 1966, shortly after the Beatles released their landmark *Revolver* album and John Lennon famously declared, "We're more popular than Jesus now." Influenced by the popular sound of the times, Darrell and his brother, Vinnie Paul Abbott, first founded their band, Pantera (Spanish for "panther"), in 1981 as a "glam" or "glitter" rock band.

Mama's in the Furnace, the Thing and More

The Alrosa Villa (named for "Al" and "Rosa") is a popular stop for heavy metal bands on their way up—or down. (CPD)

Undoubtedly, Darrell's first nickname, "Diamond," was an attempt to better fit the glam rock mold, which was flashy and colorful, personified by the likes of David Bowie and Queen's Freddie Mercury.

Perhaps it was fortunate for fans of both Pantera and glam rock that the Abbott brothers were not to achieve greatness in this musical genre. In fact, they were not to achieve greatness in the 1980s at all. It took nine years of experimentation and musical growth before Pantera would be ready for *Cowboys from Hell*, their first major label release. By that time, their overall style had evolved into something similar to "thrash metal," an aggressive musical style performed by such bands as Anthrax and Metallica, which is often seen as a reaction to the decadence of glam rock. "Diamond" Darrell was even invited to join thrash metal juggernaut Megadeth but declined because his brother was not part of the deal.

As Pantera became more popular, Darrell felt the need to change his nickname. In 1994, he became "Dimebag" Darrell, which is slang for a ten-dollar bag of marijuana. Interestingly, it was a drug issue that finally broke up Pantera, although Dimebag was not the one with the monkey on his back. Instead, it was singer Phil Anselmo's substance abuse problems that were often blamed for ending the group for good in 2003.

Abbott, of course, did not enjoy the same level of name recognition as John Lennon. However, he was famous on a lesser level. Regarded as one of the top ten metal guitarists in the world, he was praised by *Guitar Player* magazine for possessing one of "The Fifty Greatest Tones of All Time."

Although Pantera was over, the Abbott brothers were not. In 2004, they formed Damageplan and began releasing albums and touring. (The name, presumably, refers to the types of warranties that can be purchased on electronic goods.) It was while on tour later that year that Dimebag ended his career for good at the Alrosa Villa club.

In the audience that night was Nathan Gale, an emotionally disturbed young man who suffered from delusions—not quite the same delusions as Mark David Chapman, but delusions nevertheless. While attending Hi Point Joint Vocational School, he was known to make up stories about visits from his favorite band, Pantera.

School officials were so concerned about Gale's obsession with the band and the obvious lies he was telling about his friendships with band members that they called his mother. Gale's mother, Mary Clark, who worked as a waitress, sat her physically imposing, six-foot, three-inch, 266-pound son down and told him that she was tired of his nonsense. She believed the issue was resolved, and he never again mentioned the band in her presence.

A would-be musician, Gale kept journals of his own lyrics and poetry. He soon came to believe that Dimebag was stealing his songs and openly mocking him. The sad truth is that neither Darrell nor any other member of Pantera even knew Gale existed.

After graduating in 1998, Gale moved rather aimlessly through life, working the occasional minimum-wage job and abusing mind-altering drugs. He lived with his mother and frequently complained that he was being watched, which she wrote off as a side effect of his drug use. After a violent confrontation and a call to the police, she officially kicked him out of the house until he agreed to enter a drug rehabilitation program. To support himself, he panhandled and stole while sleeping on friends' sofas and in public parks. He eventually returned to his mother after agreeing to seek help for his growing drug habit.

Because of his paranoia, Gale was unable to hold a job. Then, following the terrorist attacks of September 11, 2001, he enlisted in the marines and served for two years. One Christmas while he was still in the military, his proud mother gave him a nine-millimeter semiautomatic handgun. For a single mother of an often homeless, drug-addicted son, it seemed as if her boy had finally turned his life around.

Mama's in the Furnace, the Thing and More

The good times were short-lived, though. Gale was soon given a medical discharge from the marines and, for the first time, officially diagnosed with paranoid schizophrenia. According to Chris Armold's book, *A Vulgar Display of Power* (the title is taken from Pantera's sixth album), Gale's deteriorating mental state is evident in letters written to friends and family members during his time in the military. Many of his letters and songs took on dark tones, reflecting his desire for power and to exact retribution for perceived injustices. "Vengence is mine for the taking," Gale wrote. "You will see me Fight for my life and my Right To survive/You will see Panteras Depression and on the wourlds Disorder."

Once out of the military, Gale was prescribed medications to manage his mental illness. He returned to his mother's home and was employed by Rich Cencula, owner of a local Minit Lube business. Cencula hired Gale shortly after his return to Marysville when he was called by an officer from a veterans' group. The officer assured him that Gale would make an excellent employee and had a background in mechanics. Although Cencula was not told about his mental illness, Gale volunteered that he was schizophrenic during his initial job interview. The two became friends, and Gale would often ask Cencula if he thought he was all right.

Cencula later told newspapers that Gale claimed he was taking his medication. He observed that Gale had a very close relationship with his mother, who would bring him lunch every day until she moved out of the apartment they shared and moved in with a boyfriend. With no insurance, and his mother no longer contributing to the rent, Gale had to leave his job at Cencula's to find better employment. He had been a good employee; his boss said he was sad to see him leave.

When Dimebag and Vinnie Paul came to Ohio with their new band, Gale was waiting for them. He came prepared with a loaded semiautomatic handgun, a suicide note and a plan. And it wasn't the first time. Gale had been in a similar position before. On April 5 of the same year, he had to be forcibly removed from the stage at Bogart's, a Cincinnati club, during a Damageplan performance. He caused $1,800 worth of damage to lighting and sound equipment during the scuffle with police, but neither the club nor the band chose to press charges. There is no way of knowing what Gale had in mind when he climbed the stage that day, but, coincidentally, it was on April 5, 1994, ten years earlier, that Nirvana front man and grunge rock icon Kurt Cobain died of an apparent suicide in Seattle, Washington. The anniversary of his death had received wide coverage, especially on the radio stations that played his music.

The next time Gale would share a stage with Damageplan was on December 8, 2004, twenty-four years to the day after John Lennon was gunned down on his way home. The band had arrived in Columbus that afternoon, having performed the previous night in upstate New York. Traveling with the band, as always, was their roadie and security guard Jeff "Mayhem" Thompson. Thompson had been with the Abbott brothers since their Pantera days. Apart from Gale, there were other fans in attendance who were determined to meet the always approachable Dimebag. One excited fan was Nathan Bray of Grove City. For Erin Halk, who, like Gale, was a former marine and an employee of Alrosa Villa, it was just an ordinary work night.

Gale had had a rough morning. There had been an argument between Gale and Daniel "Bo" Toler of Bear's Den Tattoo Shop in Gale's hometown of Marysville. According to reports, Gale wanted to purchase tattooing equipment from Toler. Toler told him that tattooing equipment was only available to professional tattoo artists and that Gale could not simply buy a tattoo gun. Gale became angry, called Toler a liar and left the store. Sometime later, he made the short drive to Columbus.

According to Toler, Gale had never expressed any interest in heavy metal music. Instead, he mostly talked about football, boxing and tattoos. However, Mark Green, who coached Gale on the Lima Thunder summer football team, recalled that Gale liked to listen to Pantera CDs before games to get psyched up.

Lacking a ticket, Gale could not enter the concert through the front door. Instead, he climbed over a six-foot wooden fence and sneaked in through a back door. Several concertgoers witnessed Gale's climb and even encouraged him in his effort to circumvent security. They most likely believed he was nothing more than a poor fan who could not afford the eight-dollar admission. A guard attempted to stop Gale from entering the club, but Gale quickly moved past him.

During the band's opening song, "New Found Power," Nathan Gale, wearing his customary Columbus Blue Jackets jersey, appeared on the stage and fired a gun several times directly at Darrell Abbott. It was 10:15 p.m. Immediately, fans pulled out their cellular phones and began calling 911.

Mayhem Thompson was fatally shot while trying to subdue Gale. Erin Halk may also have been attempting to disarm Gale when he was shot and killed. Several audience members were injured while trying to perform CPR on the victims. Nathan Bray was murdered while trying to save the lives of Abbott and Thompson. Chris Paluska, the tour manager, and John

Mama's in the Furnace, the Thing and More

At six feet, three inches, Nathan Gale had little difficulty scrambling over the wooden fence that separated the Alrosa's "patio" from the parking lot. (PC)

Brooks, a drum technician, were also shot and spent several days recovering at Riverside Methodist Hospital.

The horror finally ended when Columbus police officer James Niggemeyer, responding to the call, fatally shot Gale in the face. He later said that, upon entering the club and seeing that Gale was holding a hostage around the neck with a gun to his head, he knew it was a "now-or-never" scenario.

Guided by some of the patrons, Niggemeyer took a position at the rear corner of the stage and fired his shotgun at Gale's head. Afterward, he was heard to say on a videotape of the incident, "You're all witnesses. I had to do it." A subsequent investigation agreed that he was justified in killing Gale. Niggemeyer subsequently received many commendations for his actions that night and was named the 2005 Law Enforcement Officer of the Year.

The Alrosa Villa club suffered a huge financial loss as a result of the murders. One month and one day after the killings, Albert Cautela—the founder of the Alrosa Villa along with his wife, Rosa—died at the age of ninety-one. Until the incident, Cautela was known to be in good health, often working fifty-hour weeks serving drinks at the bar in the front of the club. His family believes the tragedy caused his illness and subsequent death.

A search of Gale's apartment turned up no Pantera or Damageplan music or memorabilia. A brief investigation failed to establish any connection between Gale and Phil Anselmo, the former Pantera vocalist who was feuding with the Abbott brothers. Anselmo had been quoted in the December 2004 issue of *Metal Hammer* magazine as saying, "Dimebag deserves to be beaten severely." He later expressed his regret over the remark. Meanwhile, it was determined that Gale acted alone.

In a suicide note found in his car, Gale wrote, "I Apoligize for what I Done…there is A Band using my name the Bands Name is pantera." The police also discovered the only item of Damageplan media that Gale apparently owned, a disc in the car's CD player. It was likely he was listening to the band as he drove to the club.

Although Darrell Abbott and John Lennon were both highly regarded musicians, their public personas could not have been more different. While Lennon is remembered for his musical plea to "give peace a chance," Dimebag warned (albeit tongue-in-cheek), "Here we come, reach for your gun."[26] But they both had fans who loved them—and fans who loved them a little too much. On December 8 of every year, each is publicly mourned by those who were forever changed by their lives—and their deaths.

NOTES

CHAPTER 1

1. Dr. William M. Awl, the first superintendent of the asylum, was dubbed "Dr. Cure-Awl" after once claiming a 100 percent success rate in treating his patients.
2. Howard, who published his own book of formulae and operated a pharmacy, was even able to persuade the state legislature to repeal all medical laws in 1832. But he did not live to enjoy it; his "cholera syrup" failed to save him and his family when the disease visited the city the same year.
3. Legislative action was prompted by the 1878 "Harrison Case," in which the body of John Scott Harrison, son of President William Henry Harrison and father of President Benjamin Harrison, was stolen from the family crypt in North Bend, Ohio.

CHAPTER 2

4. Shoemaker Robert F. Wolfe had arrived in Columbus 1888. In 1903, he bought the *Ohio State Journal* with his brother, Harry. Two years later, they purchased the *Columbus Dispatch*.

CHAPTER 4

5. Possibly Detective Richard Owens, who was best known for having captured Jud Holland, the "Jack the Ripper" of cow killers.

Chapter 5

6. Dundon was the first official chief of detectives in Columbus, a position that was created for him, although others had held the title unofficially.
7. It is not known if this was the dead dog discovered in the street by Everett Kimbro.

Chapter 6

8. A second suspect was a tramp who was discovered along the Big Darby a few days afterward, "ragged and soapless." He was arrested but later released for lack of evidence. He, too, disappeared forever.

Chapter 7

9. The title of this chapter is taken from a 1967 song of the same name by folk singer Janis Ian.

Chapter 8

10. Gaston and Jones may have been the models for Coffin Ed Johnson and Grave Digger Jones, the Harlem detectives created by novelist Chester Himes, a one-time resident of the Ohio Penitentiary.
11. Edwin Leavitt Clarke, a sociologist at Oberlin College, included this case in his book, *The Art of Straight Thinking: A Primer of Scientific Method for Social Inquiry* (New York: D. Appleton and Company, 1929).

Chapter 9

12. Murphy was Franklin County coroner from 1924 to 1931. In 1929, he was nicknamed "Suicide" Murphy after ruling that a Detroit gangster whose bullet-riddled body was found in a ditch had killed himself.
13. Author Charles R. Corbin discussed the case of Addie Sheatsley in his book, *Why News Is News* (New York: Ronald Press Company, 1928).

Chapter 10

14. Newark was the hometown of Snook's wife, Helen Marple. Clearly, Snook wasn't a particularly imaginative liar.
15. Ohio Penitentiary warden Preston Thomas claimed that Snook confessed just prior to his execution that the murder had been premeditated and his defense had been totally fabricated.

Chapter 11

16. Ohio University English professor Daniel Keyes wrote *Unveiling Claudia: A True Story of Serial Murder* (1986) to explain how Yasko knew so much about the murder scene. It turns out she had visited McCann's house soon after the murders took place, along with someone called "Bisexual Brady," to look for McCann's drug stash.

Chapter 12

17. "Subsidy publisher" Edhward Uhlan, the high school dropout who founded Exposition Press, later said he was the one who gave Drummond this bit of advice but would not have published a "blueprint" for committing a crime.

Chapter 13

18. Edward Doherty, in "The Twilight of the Gangster" (*Liberty Magazine*, October 24, 1931), posed the question, "How much longer are we going to put up with him?" because so many innocent victims were being caught in the crossfire.

Chapter 14

19. "Like a brick mason working with gloves," Morris once told a *Dispatch* reporter, "as a homicide detective you develop calluses on your soul. To some degree, death affects everyone, but you have to mentally shift gears to do your job."

20. The investigation also revealed that at the time of the murders, an armed, off-duty Columbus police officer was less than thirty feet away in an outpatient area, waiting while his wife was being tested.
21. In a strange epilogue to the story of Matix and Platt, two years later, George Frase and Robert E. Stone, both nineteen, attempted to rob a sixteen-year-old boy from Grove City, Ohio, because they believed he was a drug dealer. They told police they were inspired by the made-for-TV movie *In the Line of Duty: The FBI Murders*, which starred Michael Gross and David Soul as Matix and Platt.

Chapter 15

22. The other was a local high school student playing hooky from class. He was later released. Police did not believe the young man was likely to skip school again.
23. Director Luc Besson's 1999 film about the life of Joan of Arc was said to be Jennings's favorite.

Chapter 16

24. Dimebag's beverage of choice.
25. During his Beatle days, Lennon purportedly predicted during an interview that he would "probably be popped off by some loony."
26. "Cowboys from Hell," written by Pantera.

BIBLIOGRAPHY

NEWSPAPERS

Cleveland Plain Dealer
Columbus Citizen
Columbus Citizen-Journal
Columbus Dispatch
Columbus Post-Press
Columbus Star
Miami News
New York Times
Ohio State Journal
Other Paper

BOOKS AND ARTICLES

Armold, Chris. *A Vulgar Display of Power.* Crystal River, FL: MJS Music Publications, 2007.
Baron, Thomas G. *History of the Columbus Police Department.* Columbus, OH: Police Benevolent Association, 1900.
———. *History of the Columbus Police Department.* Columbus, OH: Columbus Police Benevolent Association, 1908.
Crain, Zac. *Black Tooth Grin.* Cambridge, MA: Da Capo Press, 2009.
Creighton, Rev. Joseph H. *Life and Times of Joseph H. Creighton, A.M.* Cincinnati, OH: Press of Western Methodist Book Concern, 1899.

Bibliography

Department of Justice. *Shooting Incident 4/11/86, Miami, FL (BUFILE: 62-121996)*. Washington, D.C.: Federal Bureau of Investigation, 1996.

Felter, Harvey Wickes. *History of the Eclectic Medical Institute, Cincinnati, Ohio, 1945–1902*. Cincinnati, OH: 1902.

Ghose, Dave. "The Talented Mr. Whiteside." *Columbus Monthly*, February 5, 2010.

Kevlin, T.A. *Headless Man in a Topless Bar*. Indianapolis, IN: Dog Ear Publishing, 2007.

Kunen, James S. "An FBI Shoot-Out in Miami Leaves Four Dead, Five Wounded and Some Lingering Mysteries." *People*, May 5, 1986.

Meyers, David, and Elise Meyers. *Central Ohio's Historic Prisons*. Charleston, SC: Arcadia Publishing, 2008.

Queen, Bill. *A Year of Fear*. Newark, OH: self-published, 2005.

Redder, George. *The Flight Instructor Murders*. Hicksville, NY: Exposition Press, 1977.

Shaw, Alonzo B. *Trails in Shadow Land*. Columbus, OH: Hann & Adair Printing Co., 1910.

Thomas, Robert D., ed. *Columbus Unforgettables Volumes I–III*. Columbus, OH: self-published, 1983, 1986, 1991.

Weisheimer, Carl H. *Sellsville, circa 1900*. Columbus, OH: self-published, 1971.

Wilbanks, William. *Forgotten Heroes: Officers Killed in Dade County 1895–1995*. Nashville, TN: Turner Publishing Company, 1997.

Yocum, Robin. *Dead Before Deadline…and Other Tales from the Police Beat*. Akron, OH: University of Akron Press, 2004.

ABOUT THE AUTHORS

The father-daughter team of David Meyers and Elise Meyers Walker are lifelong residents of Columbus, Ohio. David has authored or coauthored a half dozen previous works, including *Columbus Unforgettables*; *Listen for the Jazz*; *Columbus: The Musical Crossroads* and *The Last Christmas Carol*. A freelance writer and photographer, Elise was also a performer at Disney World and a member of a professional theatre company in New York. They previously collaborated on *Central Ohio's Historic Prisons*.

Elise Meyers Walker and her father, David Meyers. *Courtesy of Beverly Meyers.*

Visit us at
www.historypress.net

This title is also available as an e-book